Patrick Lichfield

CREATING THE UNIPART CALENDAR

Patrick Lichfield

CREATING THE UNIPART
CALENDAR

Patrick Lichfield
with text by Richard North

Collins
8 Grafton Street, London W1
1983

Previous books by Patrick Lichfield
and Richard North
PATRICK LICHFIELD'S UNIPART CALENDAR BOOK

Previous books by Patrick Lichfield
THE COUNTRY LIFE BOOK OF EUROPE'S ROYAL FAMILIES
THE MOST BEAUTIFUL WOMEN
LICHFIELD ON PHOTOGRAPHY
A ROYAL ALBUM

William Collins Sons and Co Ltd
London · Glasgow · Sydney · Auckland
Toronto · Johannesburg

First published in Great Britain 1983
© Colour illustrations Unipart Ltd 1983
© Black and white illustrations Patrick Lichfield 1983
© Text Richard North 1983
 Black & White photographs by Chalky Whyte

Lichfield, Patrick
 Creating the Unipart Calendar
 1. Composition (Photography)
 I. Title II. North, Richard
 770'.1'1 TR179

 ISBN 0 00 217186 4
 ISBN 0 00 217187 2 Pbk

The dates on the colour photographs refer to the year of the
Calendar shoots, in each case for the Calendar of the
following year.

Designed by Ashted Dastor
Set in Stymie Light & Extra Bold
by CTL Computer Typesetters Ltd, Leeds
Colour Separations by Gilchrist Bros, Leeds
Made and Printed in Great Britain
by W. S. Cowell Ltd, Ipswich

CONTENTS

CREATING THE UNIPART CALENDAR

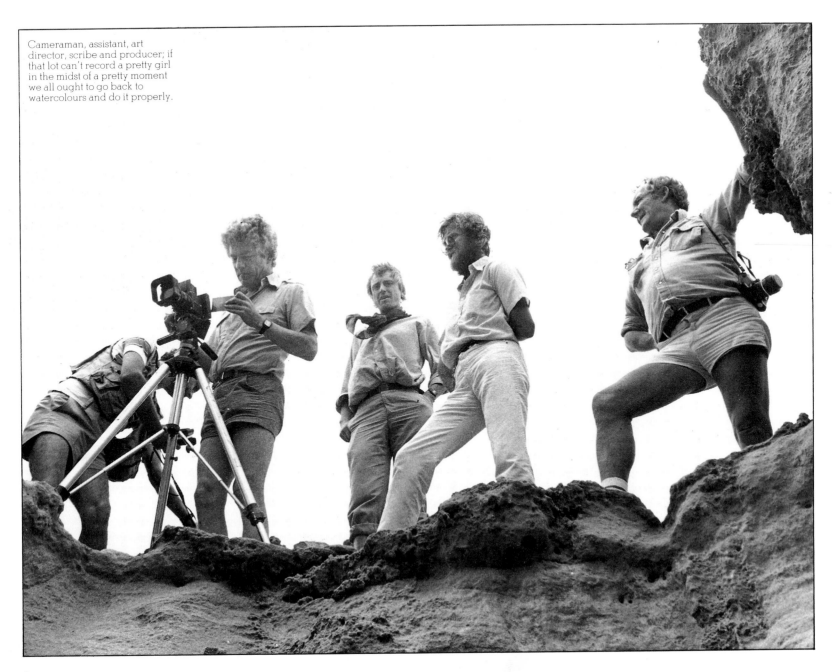

Cameraman, assistant, art director, scribe and producer; if that lot can't record a pretty girl in the midst of a pretty moment we all ought to go back to watercolours and do it properly.

INTRODUCTION

This is a book about the making of the sixth Unipart Calendar which has been photographed by Patrick Lichfield and his team. It is an account of the ups and downs of getting twelve pictures of pretty girls. It is an account of good times and bad at home and abroad during which, at different moments, the team's members were wonderfully cheerful or frankly vituperative.

If you think the fuss and bother is hardly justified, even by the lovely pictures which make the bigger part of the book, remember that the professional photographer is not allowed the luxury of failure; the occasional brilliant snap will not keep his studio in business. Lichfield and the army of pros who make rich livings from the implacable little black boxes made by diligent Japanese, Germans, Swiss and Swedes must deliver a reliable perfection and do it on time and to budget.

They have to please the client.

Unipart's Calendar must be sexy, but not too sexy. It is required to be titilating, but not rude. It must be lovely but not arty. It must be original but not *recherché*.

As to getting the work done within a cash limit: darling old Unipart, whose answer is supposed always to be Yes (remember those ads?), might rather be expected to say No if any Lichfieldian whim took them into extravagance. Actually, the £30,000 the 'shoot' itself is said to cost, and the £60,000 which the printing is said to cost, are pretty well worth spending, and that by the hardest criterion of all.

Unipart as a company is very profitable. And within the Unipart profit, a certain amount is due to the Calendar. Lichfield and those beautiful girls in exotic places are not merely cheerful and pretty; the Calendar is sold by Unipart, and *it makes money for the company*.

To anyone who wonders whether in 1983 it isn't slightly sexist to take pictures of nearly nude girls for men to gloat over, one might remark that any man who fancies a gloat can now go to any beach and see more – much more – than he will see in the Calendar. Besides, amongst the many fans of the Calendar are a good few of its male purchasers' wives. And as a

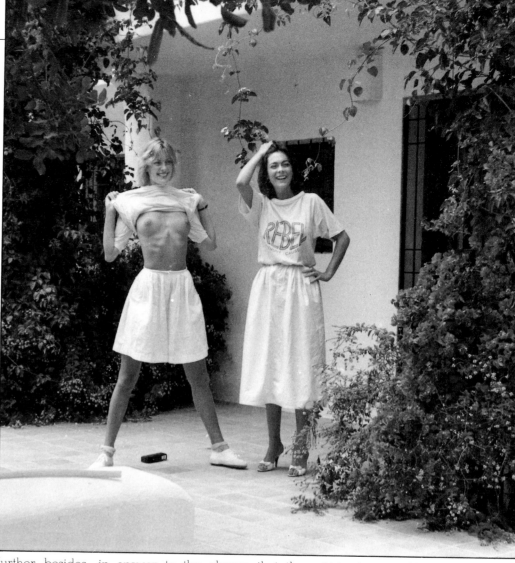

Melissa's irrepressible challenge to anyone's exposure meter.

further besides, in answer to the charge that the models are somehow exploited, it is worth saying that I have known beautiful models and ardent feminists in about equal number (and one or two were located in the same person); of the two groups (and they do rather seldom overlap) I should say the former were generally a good deal more sorted out about their sexuality and gender.

But let's not be too serious, oh dear me no.

It is one of the merits of the Lichfield team that they all knew, from first to last, that going to a sunny place and living well there whilst trying to do justice to beautiful girls in beautiful places could never be described as unpleasant work.

By delicious chance, the middle of the day is a bad time to take photographs, and by another delicious chance, Lichfield likes working in daylight. That left lunchtime and dinner time for fun. The food and drink on Ibiza are cheap and good and plentiful. I shouldn't like anyone to think that our life was dull.

I hope these pages will give some impression of some of the fun we had.

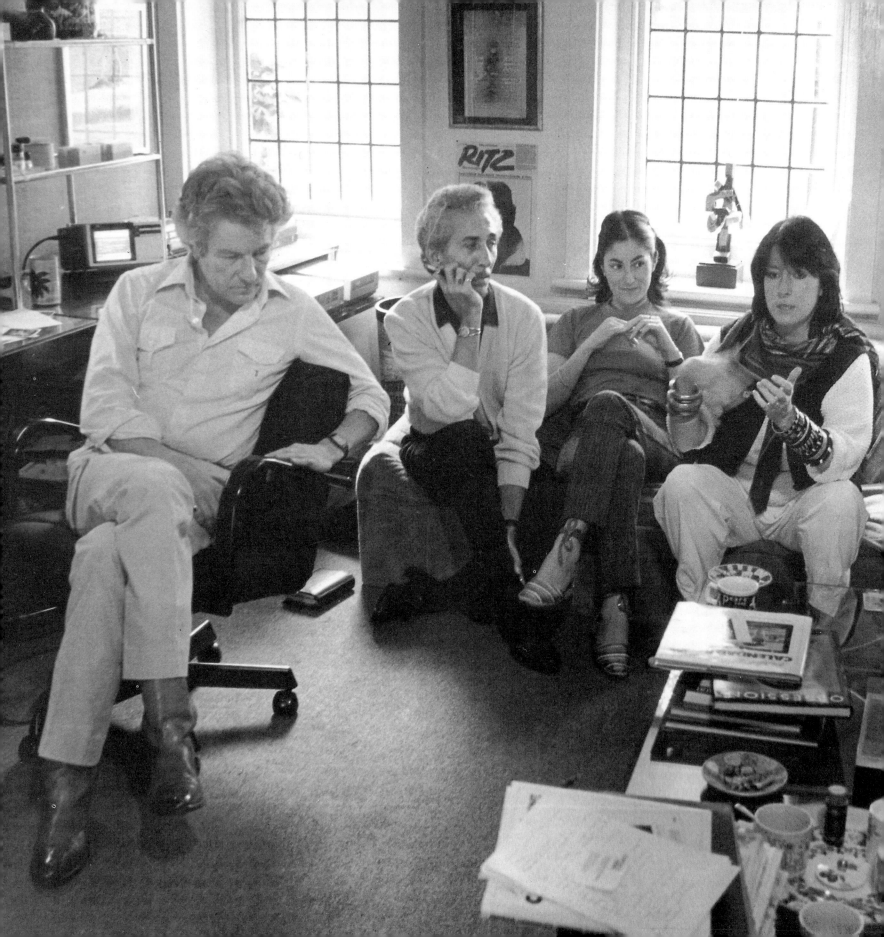

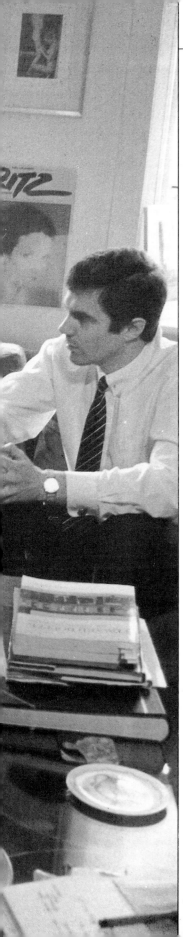

4 May

THE START OF IT ALL

Minding my own business on Tottenham Court Road, trying to buy bits of stationery for a book I'm writing.

Beep, beep. The Radiopager tells me to call home. Would I ring Robin Baird-Smith, the man from Collins, the publishers? Of course: he's one of the few people who talks serious potatoes.

Brr, Brr. 'Do you want a holiday in Spain?' he asks. My heart half sinks: publishers never, ever give writers holidays: they eat them for dinner, rather.

It's another project with Lichfield, a bit like the first (which produced a book a year ago). Am I interested? What does it matter if *I* am? The bank manager will be. The answer's yes.

My agent, Mr Ten Per Center, goes to work on Mr Robin Baird-Smith, and a deal is struck which should keep the kids in orange juice for a week or two.

25 May

CASTLES IN CASTILLE OR CLAPBOARD IN CAPE COD?

Robin Baird-Smith, I, Lichfield, and Patrick Fitz-Gibbon, the man from Unipart, all gather at Lichfield's dinky studio to discuss the Calendar and the book. Lichfield immediately tosses in the new thought that actually it ought to be shot in America rather than in Spain. He's fed up with castles and châteaux and rather fancies a change.

Patrick, Clayton Howard, Sophie Graham, Jackie Crier, and Peter Soddy of Unipart at a planning session in the Lichfield Studio. At this point they knew they were going somewhere, but didn't know where; and knew they would be taking models, but didn't know who.

There are tell-tale books of pictures by Edward Hopper and Andrew Wyeth on the gleaming coffee table, alongside the copies of *Playboy* which are clearly there to keep people on their creative toes. Sebastian Keep, the charismatic production man who must seek out locations and make all the travel arrangements, has already had a look at Spain, and is in the air to New York, Boston and points North East, as we speak.

A woman from the *Daily Mail* is shortly to come to the studio and see a casting session, during which the last four or six girls will be whittled down to three. Because of her, the final casting session cannot be nude, though all the others have been and this one normally would be.

Noel Myers, the art director, is temporarily living in South Africa, and cannot be shown the videos of the girls so far, replete with the sound of their voices, because they are too rude for South African customs.

Lichfield phones him to let him know that his creative energies may have to be bent toward America's salty east coast, rather than parched Spain.

3 June

CASTING SESSION

The studio is really humming. Spain is likely to be confirmed, by whatever back-door politicking.

There is a dotty little American TV profile of Lichfield burbling away on the video machine: someone has asked to see it.

The insolent fellow of an interviewer says that many girls have been 'Lichfielded', whatever that means. Then he calls his Lordship a 'lounge lizard'. Lucky he's an ocean away, or our man would have bloodied his nose for him.

The hair stylist, Sophie, and Clayton Howard, the make-up man, are in attendance, side by side on the sofa. They are there to cast a professional eye over the auditioning girls. It would not flatter anyone but the most perfectly beautiful to be within earshot of these two. They can detect the potential of a girl's skin to be ... well, a little corned-beefish, or a little pasty, at a glance.

CREATING THE UNIPART CALENDAR

They look at her figure with a kind of chilling coolness: in conference with Lichfield, they notice, and mention in an undertone, any slight thickness in the ankle, any slight heaviness in the bum, which puts some ravishing beauty out of the running. The worst thing, the thing all the girls are monitored for with the utmost ruthlessness, is 'ribbiness'. Considering the desperate lengths most people go to to shed weight, and the immense hunger in the rich world for slenderness, it may seem a bit surprising that these girls, who have achieved it with a vengeance, are sometimes seen as just a little too honed-down.

In the girls come. They parade before us all: shy in their extraordinary loveliness, walking on staggeringly high high heels. They look modest and almost beseeching: inviting our sympathy but not our condescension. And then they slip off the little beachrobes they're wearing, like boxers going into the ring, and begin to disappear into that world where they are almost a little removed from their bodies, which are put on display.

Suddenly a girl went from a slightly over-made-up, nervous creature, almost apologetically deflated in her robe, and stood side-on to the implacable video camera, arched her arms overhead, gathering up her hair as she did so, shrugging off her girl-next-door quality. Her stomach curved like an archer's bow, her bum stuck out emblematically at the wall and she looked as wordly wise, as deliberately sexy, as can only a girl who understands the demands of a camera lens.

The girl obeys Lichfield's commands quickly and without fuss. If she doesn't understand them, for a moment the whole edifice of pretence collapses and she is just a girl shrugging her shoulders and making quizzical faces. 'I just need you to turn a little bit more this way,' calls out Lichfield, more clearly, and then the pose is adopted again and the girl disappears behind the business of projecting her body.

None of this was sexy or alluring.

It goes on, in fact, almost absent-mindedly. Lichfield is busy with the video camera and shooting off the occasional Polaroid (the instant film is clamped onto the back of the studio Hasselblad), the assistants, Chalky Whyte and Pedro (Peter) Kain are busy with

lights and changing film. Sophie and Clayton's interest is entirely that of people who must not miss anything, but on technical grounds. The lady from the *Mail* has her notebook at the ready. She is currently perched on a sofa receiving the words of wonder from Patrick Fitz-Gibbon. He is describing Unipart in terms which would make you believe that it is a firm with the technical skill of NASA, the marketing *nous* of the Holy Roman Church, the capacity for profit-making of a goose whose eggs would truly earn the old Golden Lay tag.

'But if your car bits·are so good, why don't they sell themselves without the need for calendars?' she asks him, as anyone must. He's heard it all before of course, and fences with the view that Unipart is using every device to put its brand name in front of the customer.

But she asks – and it seems reasonable enough, though from the pre-packed Fitz-Gibbon response you know well enough that he's heard this one before too – why, she asks, do you need girls? Wouldn't beautiful landscapes or animals do? What's the relevance of girls to cars, particularly? 'Well,' says the well-rehearsed PR, 'they're both bodywork, aren't they?' It's a ploy which would have worked better with a bloke, I suspect.

The writer goes off to confer with the girls upstairs in their minute changing-room, where all the candidates to become amongst the most gloated-over bodies of 1984 are getting out of their street gear and into bikinis.

There is of course some consternation about the possibility that it may not after all be America but Spain where the Calendar is to be shot. Does this affect the sort of girl required? Do there need to be *senoritas* in Spain, but Katharine Hepburn college girls for America? Would the inclusion of the darkest of the girls be a tactical move which would stand them in good stead either way? And what a pity it is, says Lichfield, that there are so few blondes.

So few blondes? You'd have thought the nation was knee-deep in every kind of blonde. Not a bit of it, opines he: they are as gold dust.

The video has changed now, and we're looking at some of the girls as filmed at their first audition. This time they are each naked: the little ikon of a screen

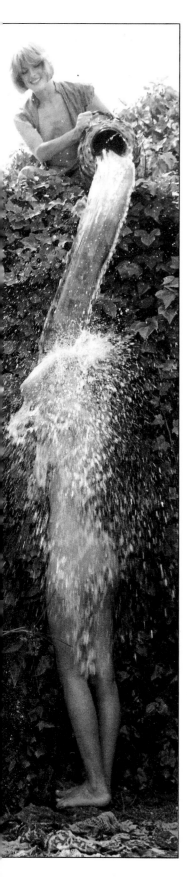

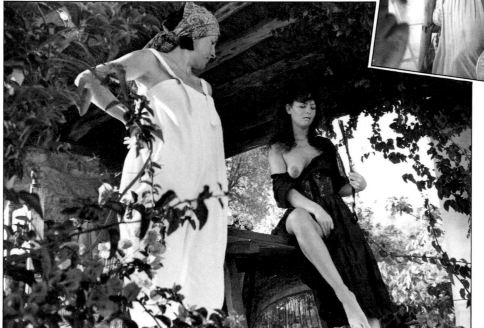

One more rock cake and Gina's Moorish bodice will give up the unequal task entirely.

Debbie gets the last once-over from Jackie, in preparation for the ultimate Spanish shot, which became something called the 'the mailer': it promotes the Calendar to the punters.

glittering on the office desk, with assorted members of the Lichfield team poring over it, makes a Keystone Cop short of each of the girls' appearance, as Lichfield spins through the less likely girls in fast motion, so that they pirouette, and arch, and show the camera their bottoms in a staccato presentation. We slow down for the likelier contenders, crawling through their seconds on the tape, and stopping in freeze frame to admire one or other of their perfect features and anatomies.

An outsider or an ordinary punter might find it difficult to grasp what's going on here. The lopsidedness of a breast, the fullness of a buttock, might be the most erotic part of a woman to her lover. To the makers of girlie calendars they are blemishes in the particular kind of perfection they seek on our behalf.

The shot you see in colour pages may look subtle enought to you: this is how Melissa preferred the picture be done.

'Now isn't that wonderful?' the team suddenly agree of a girl. Certainly she is lovely. But it is the way her physique scores against some arcane list, as a pedigree of a some exquisite breed of animal might, that is so startling. It seems arbitrary: it is a combination, in fact, of some of the qualities needed in a fashion model and of something more earthy. It shouldn't worry anyone that they do or don't fulfil the extremely rare norm they're after.

But, Lord knows, getting jobs is more fun than losing them, and all auditions and job interviews are horrendous. Perhaps there is something more awful in this business: the girls are being judged about 'assets' which are bound to be close to their hearts and which they have put on the line.

The video is still burbling on, and the Polaroids are scattered on the table. The choice is being narrowed down, and seems to have settled on three excellent girls. 'What a lovely boat [boat race: face, in the argot],' exclaims Clayton of one girl.

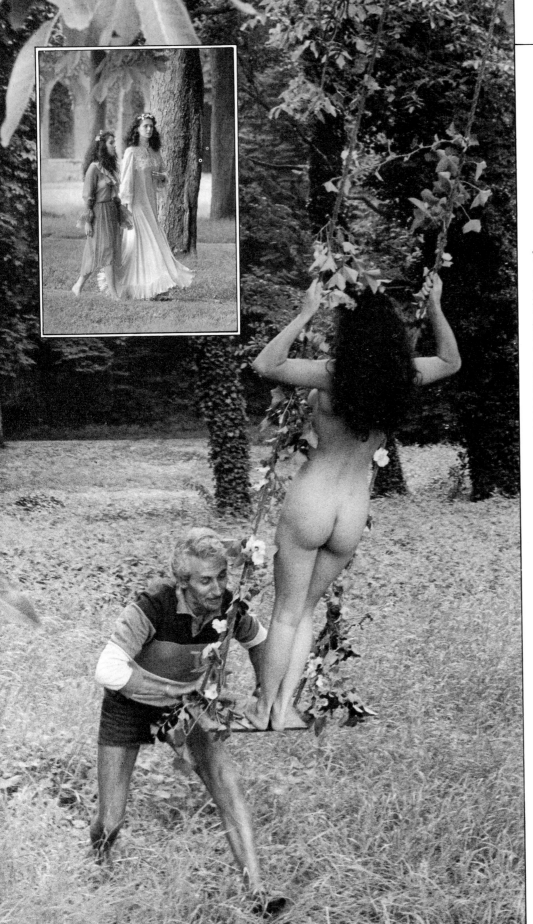

7 June

UPDATE

I have grown tired of wondering where we might be going for the shoot for the 1984 Calendar. Might be anywhere. I go down to Lichfield's studio to be brought up to date on the Calendar shot in 1982, which is on the walls of the nation's garages just now.

Not being a garage hand, I hadn't seen it before. It looks better than ever. It happened in the grounds of a lovely French château which belonged to Napoleon's mother. For all I know, the old girl would not disapprove of its now being draped and hung about with the lively lovelies of a Unipart Calendar. On the other hand, she may see it as Wellington's last dirty deed. Anyway, she gets no choice, and the current grand and ducal owner told Lichfield that he thought the place looked better for a little life being lived in it.

'Actually,' says Patrick, 'he seemed more concerned to talk about horse racing than anything else'.

They had found a place where no one bothered the team, and had taken over a classy chef to keep the party fed. 'Not all of us cared much about food,' says Patrick. 'Calf's head didn't go down too well with some of them'.

Still, without doubt it's the most clever and accomplished Calendar of them all. No doubt about it, the team will be pushed to come up with a better piece of work this time. They have mastered technical complexities as well as aesthetic intuition: the work in the summer of 1983 will be demanding.

'There was something about the French shoot which came from a memory I have of my grandmother telling

The athlete behind the effortless look of the thing: Debbie can't be expected to look gorgeous and simultaneously functional on her flower-decked swing. In the end, the picture didn't make it to the Calendar.

Inset
The one that got away: two girls photographed fully-clothed is not the usual Unipart form. Blokes feel oddly excluded from these colloquies between girls.

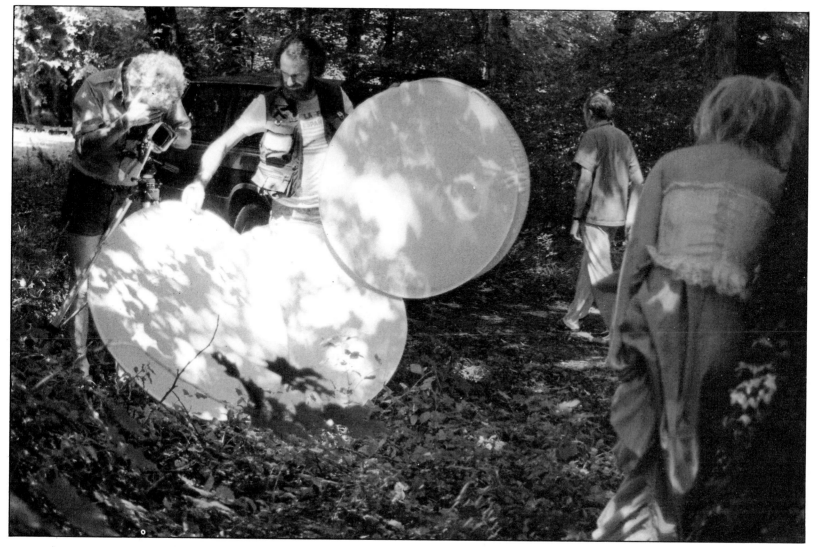

me how there were parties in her time in which youngsters in grand frocks would play in bare feet. There was a freedom they devised for themselves in that rather restricted background,' says Lichfield, of the linened frolics which were the theme of the 1983 Calendar.

'Very often the things with the greatest amount of planning behind them turn out to be useless,' says Lichfield: it happens that the French shoot evolved out of a certain absence of definite plan. Sebastian found the place whilst travelling back from somewhere else. The books which informed the Lichfield eye about the fine detail of the *Belle Epoque* theme were, of course, readily found. The clothes came from Jackie's tours of *costumiers,* and the fine tuning of the look from her intuitive grasp of how to throw a visual party to order.

After so many calendar shoots, the French project needed something special. The year before, the team had ventured about as far as they dare into a lesbian world of vaguely, if jokey, sinister overtones. 'This time, I decided we would have a really innocent, sisterly sort of effect,' says Lichfield.

Not to be left behind in the technology stakes, here is a little snippet for the *aficionados* (culled from what Patrick told *Amateur Photographer,* so it's probably about right): 'Because I wanted to emulate the photographic style from around the turn of the century, softness and low contrast were essential, plus grain (though film emulsions 80 years ago were good, they weren't without a certain graininess). With colour transparencies you have to get it right first time. Grain needed careful control. If you just uprate any kind of film indiscriminately you'll end up with clumpy, messy grain, rather than the crisp grain I was going for.'

The team tried dozens of permutations of filters and film speed, in London, so they knew fairly certainly what would be going on inside the Hasselblads when they got to Château le Pont-sur-Seine.

Lichfield reckons he finally worked out how the shoot should go when he had Sally stood up in the slimy old pond, and young Nike wandered by, creating a blur in the background of the test Polaroid. 'The effect was a bit like some of Latigue's early work,' says Lichfield.

Nike can look even better if ministered to by strategically placed reflectors which light the parts the sun cannot reach.

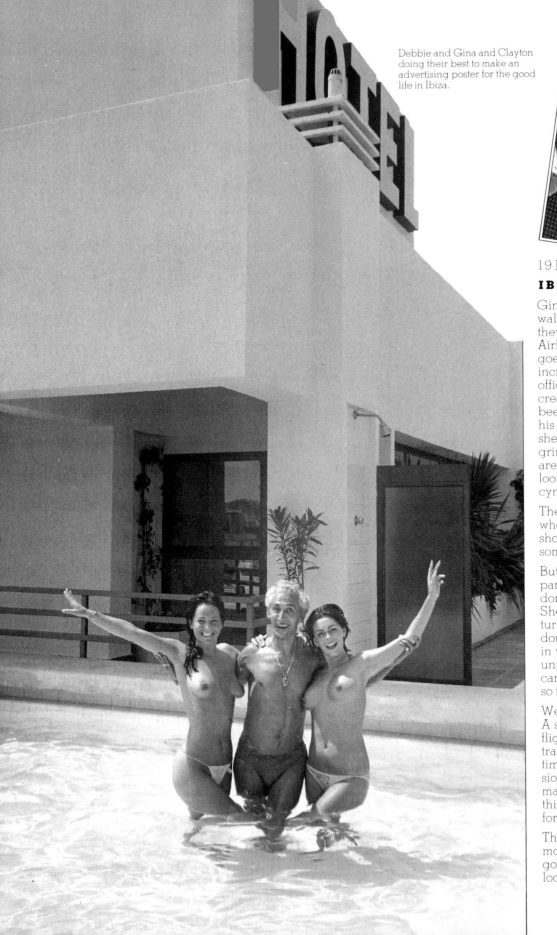

Debbie and Gina and Clayton doing their best to make an advertising poster for the good life in Ibiza.

19 June

IBIZA

Gina and Debbie arrive at the check-in desk. As they walk across the hall there is gathering certainty that they are models: something in the way the Iberian Airline Spaniards react to them at the desk as Gina goes forward to ask for some help or other gives an increasing feeling that these girls must be they. An official appears out of nowhere – handsome, beaming, creased about the eyes. He is glowing. A man I've been talking to idly, suddenly says, My God! and stops his shop talk. Gina at the counter is giving as good as she gets: throwing back the banter with a practised grin which has grown out of long acceptance that men are put into overdrive by her extravagantly good looks. With Melissa added to the party, we are the cynosure of all eyes.

The enquiry settled, whatever it was, Gina and Debbie wheel over their airport trolley. Their suitcases alone should ensure that the Iberia Flight 501 may have some difficulty limping out of Heathrow.

But they are as nothing to what's coming. Bit by bit the party accretes: but when stylist Jackie Crier's Pandora's boxes arrive, we know that we are in business. She has packed for a fantasy crew: trunk upon trunk turns up. There's an ex-royal duty portmanteau donated to the team by Lichfield: a stout, sturdy affair in which you could comfortably park the remains of an unpopular relative or two. There are flight cases with cameras, and Lichfield has brought his video machine, so that the party can make its own hi-tec holiday movie.

We aggregate all the stuff in front of the check-in desk. A small mountain of gear. We grab a drink before the flight: Lichfield has that calm of the accomplished traveller. Our flight is called again and again, but he times our departure from the bar with a careless precision which allows the first gin and tonic of the trip to make its mark on the hassled morning before we even think of queueing. Lichfield is not, I think, the world's foremost queuer.

The Ibicenco customs official wore guns, a walrus moustache, and Christ crucified was suspended by golden manacles from His wrists on his hairy chest. He looked as though he might make difficulties, but was

Old mates chat on the flight to Ibiza: Melissa was in Africa with this crew a couple of years back.

only going through the motions of surliness.

The girls snugged themselves into the hotel with all the cool of people who had been Four Star in the cradle. It's big, cool: classy, simple, and no plastic in the place.

Opposite the bull ring, mind: a week hence, when there's to be a fight, we plan to give the Spaniards a hard time for their atavistic passion for bull-wrecking. We reckon we could lob gin and tonic – or molotov – cocktails clean into the ring from the sixth-floor swimming pool.

Noel Myers, sweetly loose mouthed, and a genius in the business of getting girls to look toe-nail-meltingly sexy, is here already. He's flown in from a job on Mauritius. He is wonderfully basic. He combines a Manchester United enthusiasm for a good time with a sensitivity which doesn't always come across on the television movies which get made about the Unipart shoot. Luckily, it does get through to the girls, who use him as a kind of rough uncle.

We set off across the island: with everything having been arranged so late, there are distinct anxieties that Sebastian will be stretched to find not merely the perfect locations, but to arrange all the nonsense that goes with a Unipart shoot: food for ten or eleven; places for make-up and hairdressing. But above all, privacy: carting around the three prettiest girls in Britain half naked is not the easiest thing to do unobserved, not to say unmolested. The girls need to be relaxed, and so, indeed, does Lichfield himself.

It's a lovely, if dotty, island. Dust, and dogs on chains under trees barking their heads off and the beautiful people burning around in junky little motors whose suspensions have been abused in a way which it would probably test even the ingenuity of a British shock absorber maker to withstand. Not a lot of Unipart products about: but Range Rovers are the Rolls's of these mountainously pitted tracks.

Wonderful soil on which stunted barley ekes out a living. A soil not nowadays so much drenched in the blood of old, as in some rusted sun tan oil. This is the soil which Phoenicians and Romans, and our own adored Lord Nelson, trod. Now it is twopenny tourists and languid jetsetters who invade the privacy which should properly belong to the crotchetty peasant ladies, sitting like plump and creased crows on terraces and tearing the world apart in the required manner of ancient ladies everywhere.

What terraces! Started by the Romans, they keep these dry lands from sliding down the hills.

There are walnut and carob trees, and the hay is stacked in the way we haven't seen in Britain for fifty years.

Dull little beaches mostly, but who cares, with the sun burning down and everyone rubbing unguents on themselves like cooks marinading steaks.

Sebastian and the airline check-in man gave each other a mildly hard time as the hundreds of kilos of baggage the team had used looked excessive. Sebastian applied a great deal of quiet, unyielding, polite, hard-nosed keenness to see his gang and their bags on the flight, and reason gradually prevailed. Relief all round.

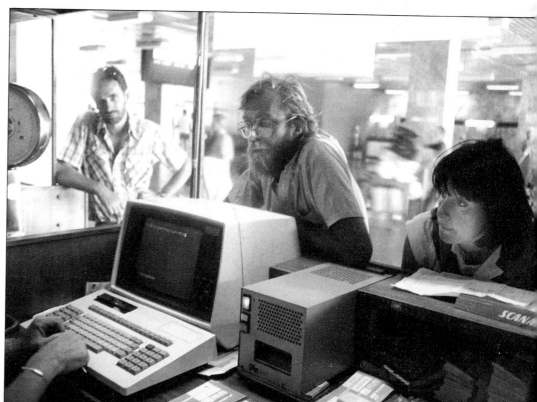

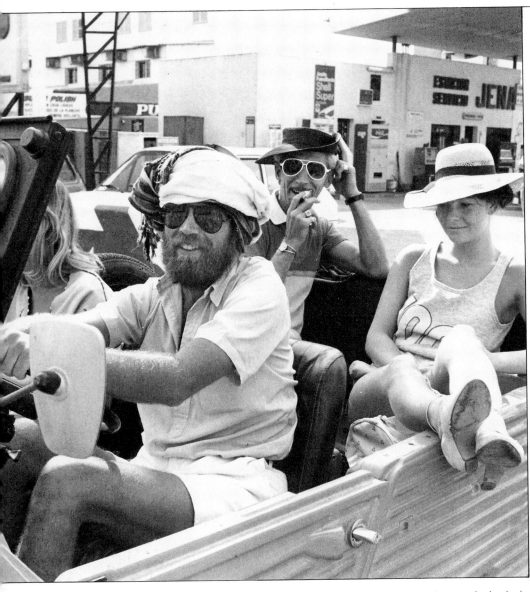

The stripped-down Citroen made the most agreeable meat wagon: half-camel, half-beach buggy, it made one feel the Foreign Legion recruiting sergeant was in town.

On one beach we spot an immense charcoaled whale of a woman who momentarily throws even Myers' devotion to the unclothed female.

And then we arrive at San Miguel, with its momentous rocks, the colour of pumice stone.

'Are we really going to do Sun, Sea and Sand?' asks Lichfield as we draw up chairs around the first pre-dinner aperitif of the trip. He looks just a shade anxious. This is frankly, the bit where he is on the line most: not able necessarily to see where the entire enterprise is going, and half inclined to turn around and go home. That can't be done, of course. Still, he hasn't seen anything which combines enough stunning loveliness with the convenience needed for such a large party. He rather favours the idea of doing a 'landscape' Calendar: one in which the photographs are shown horizontally and in which the girls themselves are relatively small. Noel, the traditionalist,

and the representative of the punter in search of glamour, looks slightly pained. Jackie Crier soothes him by stressing she's brought the bright, almost harsh, clothes whose shock effect could bring drama to a girl's shape even in a big background.

'Girls alone in mysterious places. These marvellous rocks, the olive trees, the soil,' says Lichfield, and from his tone of voice there's a feeling that he remains to be as convinced as he would like to be.

There are the lovely architectural styles of the island: especially the *fincas:* variously Moorish farmhouses with verandahs and terraces. And then there are the coves with jetties and boats. We're in with a chance, though just because the things are around and the team likes them doesn't at all mean that they are available and private. Still, the party regroups for a gang supper, and the day ends as most will: riotous games which bring the Victorian house party back to life a long way from home.

At this point it seems like fun, fun and fun.

20 June

PEOPLE

Ibiza is the kind of place which is stuffed full of people who never left the Sixties behind. Limpid people who use Ibiza as a kind of King's Road with sun lamps. They bear all the signs of believing that everything after about 1975 was rather wearisome. Some of them look as though they were out to lunch, as they say, in the Sixties and are – one might say – only now getting round to tea. Lord knows when they'll serve dinner.

In Ibiza, it's bound to be late, according to the newest member of the team. Chloe is an ex-model who could still stop most of a High Street by nothing more exerting than a walk down it. She knows everybody and talks with a Roedean voice she actually learned in a convent. The years, to put it mildly, have treated her extraordinarily well. Her favourite expressions are 'Mad' and 'Romantic', and she likes people who are either. She says them with all the letter A's turned into E's. She is the vowel-transposer of all time. 'Sabestiun,' she cries down the street when she arrives, 'How febulous.' We all love her very much, though Chalky

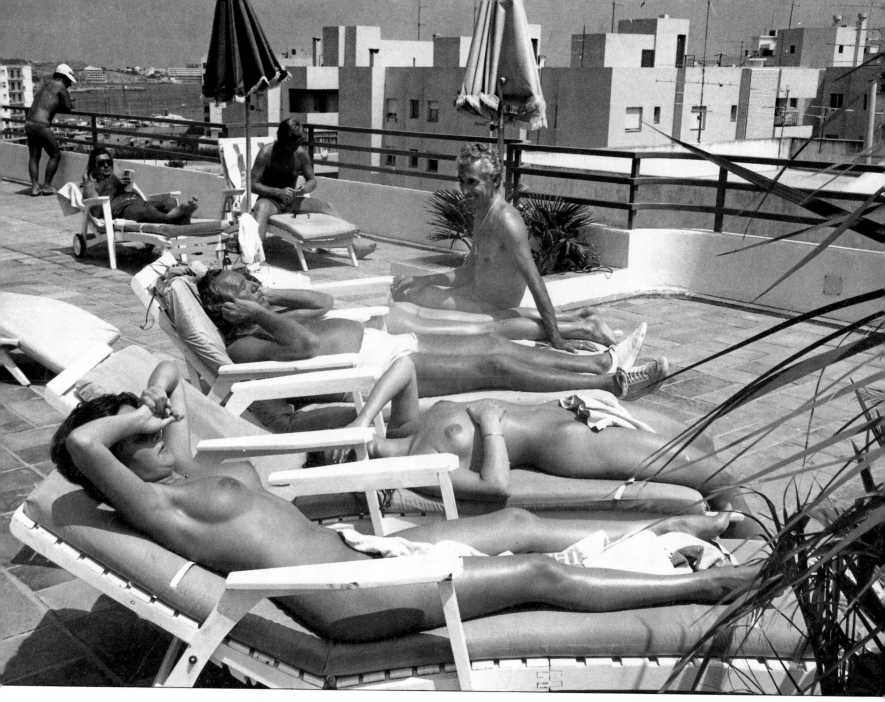

Whyte goes spare later when she drives some of the crew around. Third gear is achieved very seldom and she has difficulty overtaking a donkey cart. Her smile makes the sun look like a torch with flat batteries.

We are looking for contacts: hunting out the people with the houses we might use. Sandy's Bar in Santa Eulalia is where everyone goes: but not till eleven (Ibicincan breakfast time for the expats). Chloe tells us how time works on the island but we don't believe her. Instead we race around trying to hassle this and expedite that. We are clearly being 'med' and eventually do hove into Sandy's at about noon. The Lotus Eaters, these beautiful people with nothing to do and who go to the task with a will, are just rubbing the sleepy dust out of their bomb-sited eyes.

We have lunch in a beachside restaurant and begin to think that we too are the beautiful people.

The girls are resting up in the hotel. Some cynic suggests that since they must by now be up, it is very probable that they'll be sunbathing. These youngsters look as though they could live on a diet of Lotus without any bother at all. Here are we flogging round the island trying to find places against which they will look beautiful and become famous, whilst they sun themselves. Oh, woe!

'Just do my back, would you?': Clayton making sure the all-over tan is 100 per cent.

17

CREATING THE UNIPART CALENDAR

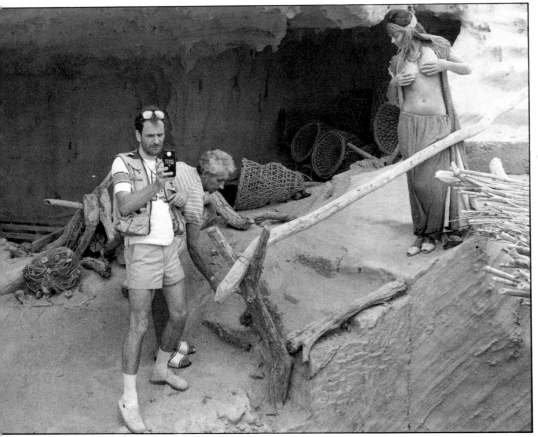

You cannot leave everything to inspiration and Creation's bounty. Gina attends to her breasts whilst Pedro attends to his readings.

It is a piece of heaven: a barren hillside transformed into an England coolness: five thousand tons of water a year keep it so.

Bougainvillea blazes its lilac devastation down one wall, and wisteria makes a tracery down another.

The house is Moorish but modern. It is adobe, with aerials. Things are the tiniest bit edgy. Worse than that: Lichfield has a bit of a feeling that we're in trouble. The rich man's house does help somewhat, it's true. There's exotica and privacy: what we're after. But there is the difficulty that there is no theme yet. 'Slight, mild panic,' he says, with the sort of smile that only a person who by the deployment of a certain amount of bottle in the past has got out of bother may deploy. It dawns on one that the man is honest: odd, that, in view of the life he lives and the worlds he moves in. A fairly straight fellow, somehow. Might give someone a hard time, might be a bit cruel if he allowed himself, or anybody else did. But not a fibber about his anxieties, any more than about his strengths or successes.

He makes himself feel better by saying, suddenly: 'Actually, old bean [an expression he never uses without just a dash of irony], we've got enough rejects from past years to just about get through even if we never took another one this year.' We fall to wondering whether or not we could get away with it. Probably not. The client – darling old Unipart – might notice. The worry sets back in.

Jackie and Patrick and Noel begin to have rather serious discussions about clothes, the look and theme of the thing, and how the locations we know about all fit in. 'This house,' says Lichfield, 'is too upmarket.' Our host would love that, if he could hear: blow a million or three on a squat and have a chum turn up and rubbish it as too smart: lovely.

But Patrick knows that Jackie has a peasant girl theme in her mind, and respects the way Jackie works. Besides, Jackie, at short notice, has this bright, Goya-ish gear and will punt for that. The camp followers theme is still in her mind, though it is already being modified toward the business of working girls in the countryside. These are not aristocratic creatures in plush surroundings; they are peasants in exotic ones.

Lichfield would have preferred that everyone had

The restaurateur brings out a present of a potent liqueur with some twigs of herb in it. And then some champagne. The afternoon has to be picked up and shaken by the scruff of the neck if we are to achieve anything.

How on earth can they call this work!

We've seen some houses. Lichfield is spotting arches, and steps and ladders and windows and sequestered walled gardens.
And then we go to the house of one of the richest men on the island, introduced to the place by Sandy Pratt, the island's premier garden designer and the founder, years ago, of Sandy's Bar, in Santa Eulalia.

been working on this, our second day: taking pictures, getting something under our belt. Only the lateness of the arrangements made that – the normal practice – impossible. Lichfield is not good at not working: he's a very high energy person who is used to delivering: a day spent reccying and fighting uncertainty is not his style. He is looking forward to getting on with the work. 'Something will happen when we actually get going, he says, and it's the most comfort he's felt all day.

21 June
TO WORK

We have gone back to the richest house in the world. It is a location on a plate, and completely hassle-free. By which one means that the host has pulled out all the stops. Do we want lunch? Wouldn't mind at all. No bother.

The girls are longing to get at it. Sophie, the hairdresser, remarks in the car going out to the location: 'We've had our fun day, now we want to work. It's a marvellous thing, being a part of a team and beginning work. It takes just a little while, but once things are going it's marvellous, feeling one's a part of it and watching it all come together. The charge you get when things start.'

Little Gina, the baby of the party, but up to her ears in togetherness, says, 'I'm really looking forward to working. It's preferable to all that lying about.' She is mustard, that girl, and wants to get in front of some sun and some celluloid and prove it. 'Can't stand lying about,' she says.

As Gina prepares for a picture, taking her clothes off and sitting ready in the location, she seems a child: lovely and, God knows, developed, but shy. But it is not, I think, that she has her clothes off which makes her shy. Her body is not something she worries about. It is her performance she worries about. She needn't: the Calendar needs the most peculiar mixture of innocence and brass: and she can deliver. When she looks at the camera and darts a tentative smile, hearts skip dangerous numbers of beats all around.

Melissa, who has been on a Unipart shoot before, but more than that carries a great, light, useful kitbag of self-awareness around with her, is brilliant at keeping the younger ones in tune with what's going on. The blokes are chattering their heads off, as blokes will when they're away – like football fans on a coach – but Melissa is often to be seen having words in the shell-likes of her fellow models, in the most simple of ways.

She also, this Melissa, arranges a quick frontal tit-flash, on the count of three: Gina and she stand under a

Below left
Debbie prepares to receive the works from the bedecking team, Sophie, Jackie and Clayton. The unbedecking team of Lichfield and Myers would soon remove the necklaces.

Below centre
Chalky hasn't shaved in his mirror for some time, but it really didn't take *that* long to get himself in focus.

Below right
'I don't know, Guv'nor, do you think it works?': Noel keeps Patrick up to the mark.

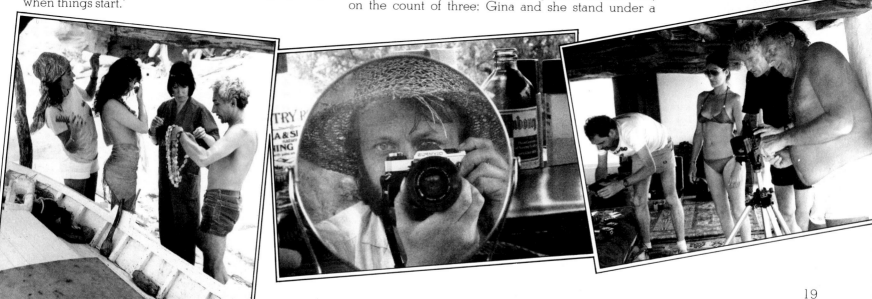

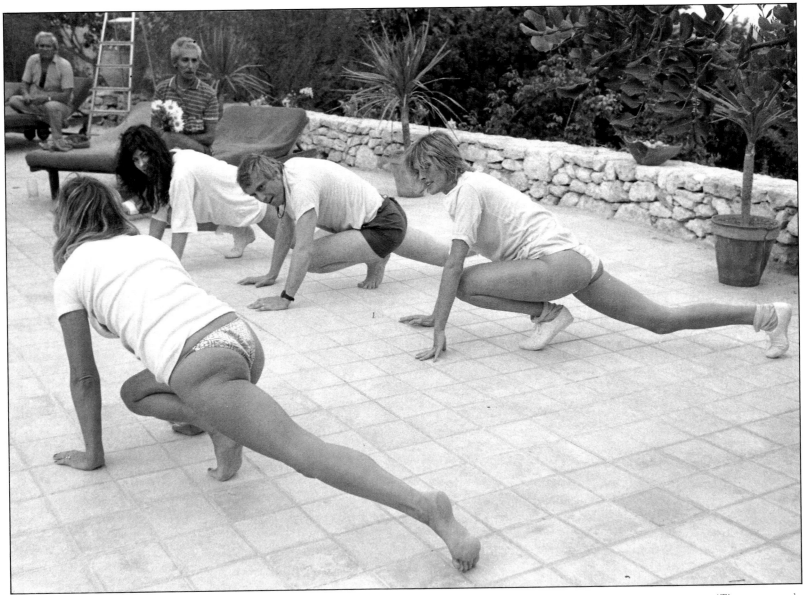

Chloe knew all about getting everyone's bits working.

porch and flap tee-shirt at the rest of the gang: one, two, three, and then the delicious exposure. It makes a prank of what must be a profession for the girls. A well chosen stunt. One up to Melissa, who will score many more. To combine such practicality with such beauty is a rare gift indeed. The day is cloudy and hot. 'We badly need one good day's work: once we're started we'll be all right,' says Lichfield.

Gina is sitting in the corner of a terrace looking a million dollars. The overwhelming impression is of modesty: it is quite disturbing. 'She loves it,' says Sophie, and I have to trust her judgement on such a delicate matter of gender.

Debbie goes so far as to say that she actually feels privileged to be amongst us all: on a team of this sort. 'It's such fun to be amongst you all.'

Gina's breasts are so phenomenal, one regards them

with an almost technical absorption. 'They are only 34",' she informs us proudly, 'but C cup!' When she slouches they are merely exquisitely formed: but as she straightens her back, they come up like elevators. Proud, torpedo-shaped almost. The nipples stare the world square in the face.

Even so, beside her in the terrace picture there is a glass with ice cubes in it: she must freeze the nipples into erection.

Debbie says she's not very interested in her body. Looks after it, of course, but isn't that keen on it. She does, this erstwhile ballet dancer, the most ferocious exercises. I try a couple of them and very nearly wrench bits of limbs from the poor old heap.

Chloe goes through a little light Jane Fonda exercising on the terrace, and then there are lovely swims in a pool you could water ski on.

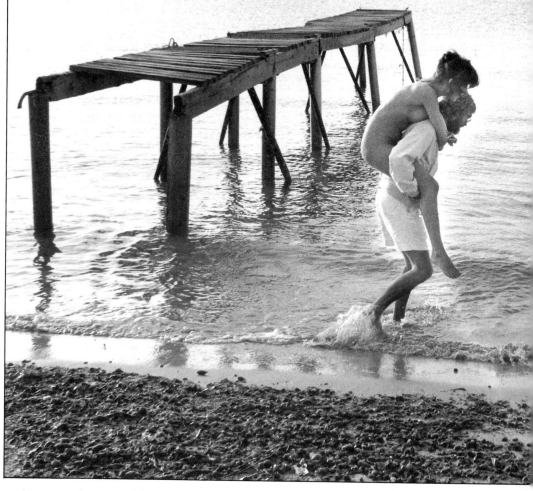

Sebastian (the beast) with Gina (the burden).

There is a lily pond, into which Melissa is made to walk: there are some exotic beetles and some very unpleasant-looking slime in the bottom of this soggy Eden. She doesn't complain remotely, and is marvellously funny at being responsive to instructions while firing off the odd rejoiner from behind her still obediently posed, smiling lips. We are bringing a touch of Millais to this hot place. We are here for business, and these are people, the girls, who have to know all there is to know about husbanding the exquisite bodies that a munificent Creation has given them . . . They know it. Young Debbie, who has the slimmest waist in the world, which swells out over a rear end of sculptured richness, talks about the work she's done so far. 'Some mother and baby things,' she says: she likes cats, that's all she knows about maternity, but there you are. 'And some underwear stuff, because I look sexy in underwear.' Easily imagined.

'I don't do glamour work,' says Debbie, 'but I'm with a glamour agency.' There are, says someone, three or four top flight glamour agencies, and perhaps a hundred girls who are really reckoned in that line of trade. But this shoot has only half a connection with glamour: it is pretty-pretty as well, though Noel Myers is in some sense the glamour-minder and keeps his eye on that department pretty closely.

Gina says that she's done some tabloid press Page Three nude work, but they didn't use it. You wanna faint now, or later? The *Sun* should be so lucky.

The picture achieves lift-off when Debbie is added. Perched in the tree in a way which combines discomfort with insecurity in about equal measure. She is learning the extremely unglamorous nature of fooling the camera lens.

It isn't a whole lot better when she gets to star in a washer-girl number on the bijou waterfall. Her left leg is being tested to a degree by the pretty but tortuously unnatural deployment of even an athletically honed limb. Frankly, after the pain I've been through in following her exercise regime, I'm delighted that she should be given all the aggravation she can take, and then some.

Lichfield is working pretty cheerfully and fast. He is much better up and doing than thinking about working, say his team. He has the good sense, as must all aristocrats who want to survive their weird lives, to prefer working to lying about. Actually, his appetite for work – really continuous work, hour after hour, day after day, week after week, year-round, and for a good deal of some fairly serious partying afterwards – is beginning to command a great deal of respect.

We are dependent totally, like a school party abroad, on the good offices of Sebastian Keep. He is alarmingly good-looking, with a beard he grows between yearly shaves. He walks with exceptional authority: not quite a swagger, but with a bossy hussle which you know means business. He possesses the poise and serious mien of the men who put an alarming proportion of the world's map into Britain's team colours. He has his tropical trousers made to his own specification, which strikes me as frightfully grand. He has a pair of shorts which are assertive, roomy and trim all at once. He carries a huge briefcase in which there are documents and banknotes. We call him the *homme d'affaires*. Lichfield always refers to him as 'my man of business', which nicely nods towards the way Patrick's ultra modern life still has a language at least, and some of the substance, of a way of life fashioned a century and more ago. 'Sebbers' does everything to do with money, mobility, meals. He is the Producer: the man who makes all the physical and financial arrangements. He is quite a heavy dude. We are all, from the first to the last of us, a little afraid of him.

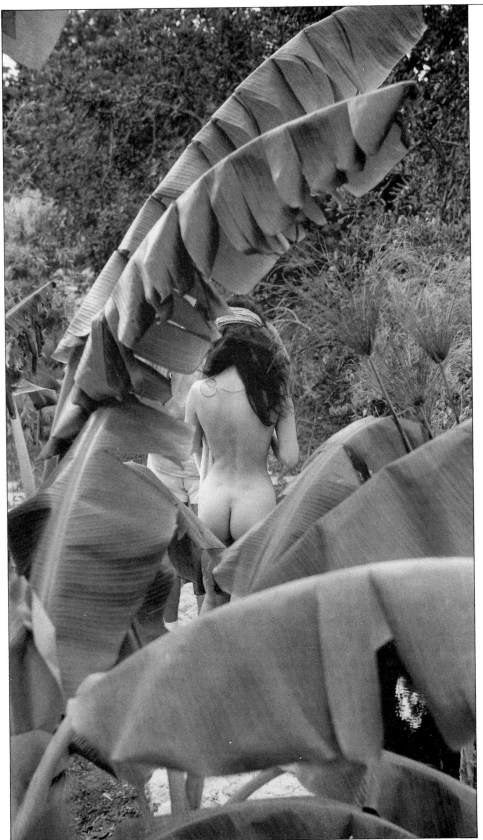

Noel is finding his way and minding his own business. There are long discussions over beers off and on through the day. A language is being developed to describe the Calendar's possibilities. The place is not ideal, and we know too little about it. But we are working toward the notion that there is a Sun, Sea and Sand option, which Noel, the old glamour king, appears to favour or not mind. There is the 'peasant girl in a world bereft of men' option. As described by Jackie, this would be quite active, and even aggressive. There might be a seamy farmyard scene with dust and chickens and tattered, once gaudy, clothes. Or several girls might be trying to push a boat out to sea, reminding the alert punter of the scenes of Nelsonic derring-do in little boats, à la C. S. Forrester, whose books, come to think of it, have the sort of undertone of sexuality that rumbles under the Lichfield enterprise. Though his girls, of course, came from the grubby-nailed background of reality

Our girls seem to come from a uniquely modern world: not classy, not deprived. They are young of course. They love cats and Debbie cries whenever she sees one and would be cross rather than motivated by any intrusion into the sheer niceness of their world.

The team seem fairly cheerful with their work so far. Three or four seriously possible shots are in the bag. One couldn't hope for much more. The feeling that many rabbits must be pulled from hats on this shoot still remains, but they are beginning to become the vestigious anxieties without which one might relax and blow the entire thing from over-confidence. They are the anxieties professionals always maintain, so as not to tempt providence.

'It's a Fragonard,' cries His Lordship, and I begin to develop the theory that he is as good as he is at combining sexiness with prettiness because he was brought up surrounded by the painterly clichés of super sophisticated shepherdesses and pretend-

Bananaskin with a difference.

22

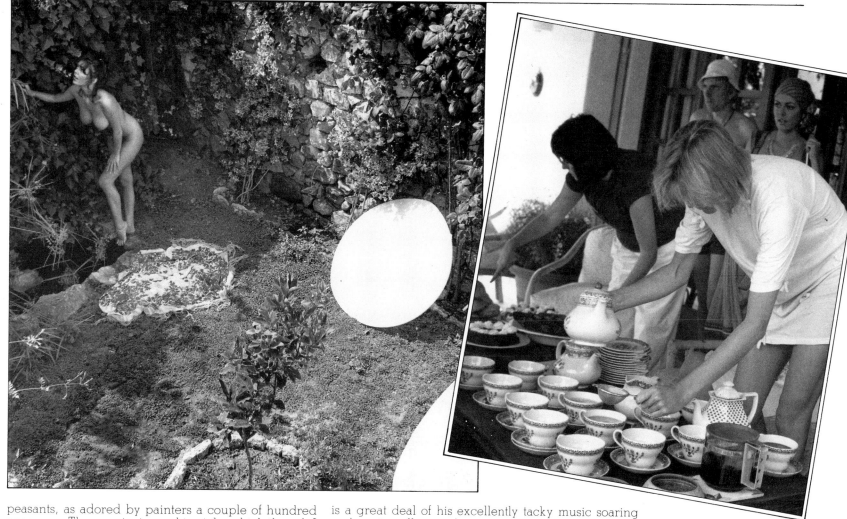

peasants, as adored by painters a couple of hundred years ago. The man is steeped in style, which though I doubt he could describe in detail, he knows how to recreate in a photographable form. His eye and style resonate against the galleries and corridors of countryhouses the length and breadth of the land.

Chalky and Pedro are very quiet and solid workers: they are careful and methodical and muscular. Their equipment hauls are fast and groan-free. Lugging the dozen or so camera bags is one thing. Keeping track of the exposed film – whose value must be immense – is something quite else. God knows how many tens of thousands the shoot costs all told: but the rolls of exposed film in Pedro and Chalky's charge are its sole outcome. They are the currency Unipart are buying with all the geld.

All work and no play would be dull indeed. Two somewhat flamboyant attendants have been slaving over hot stoves all morning. We eat in a covered barbecue area in the garden. Some extremely heavy stereo knocks a Bob Marley rhythm into the acres of plant life all around: not loud, but with a quiet power that makes those reggae hymns extremely stirring. However, the attendants prefer Julio Iglesias, and during lunch there is a great deal of his excellently tacky music soaring and searing all around.

Lunch stands a very fair chance of developing into a riot. The party is becoming extremely raucous during meal times. Chloe remarks that a famous local personality, Tits René, has named each of her breasts. This prompts from Melissa the news that naturally she has dubbed each of hers. Without ado, it is elicited that her left beauty is called Penelope and her right, Gertrude.

'Don't scrape the flesh,' cries out Myers, in a tone of voice which is solicitous, up to a point. It is also prudential . . . He has got Debbie trying a shot in which her right breast is perilously grating against a stone wall. She lifts it protectively for a moment, like a dowager tucking her peke a little more closely into the crook of her arm.

'Stop blushing!' someone very cruel shouts at Gina after someone else has cracked ribaldry about her. She wasn't, before. She is now. 'Try and get the shot now she's got that wonderful glow to her face,' cries out Sophie, who often pitches in with a little help for the overall look of the thing, quite apart from the hair.

Left
A game of hide-and-seek in progress? Gina really isn't playing it by the rules, I feel.

Right
Everything stops for tea, especially when Melissa does the honours.

23

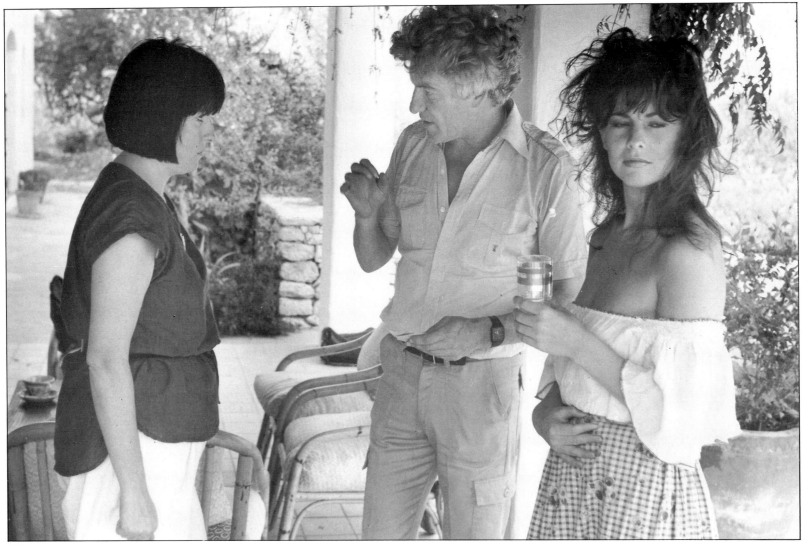

Jackie and Patrick closely debating the look they're after. Debbie has it all the time.

'Soften the mouth,' says Sophie, and a hardish pout on Melissa's very poutable mouth is made to register a quieter view of the world. Years are shed and the know-all becomes a sensuous teenager.

'Lose a bit of your hair,' cries Sophie: each of the team remembers a different aspect of the scene. You'd think one person could do it, of course. But a lot is going on in the vital seconds leading up to a shot. The technology must be right. The miniature drama of the scene must be right. The blouse must be opened in absolutely the way intended. To a degree which would surprise the casual observer of the Calendar, this is the business of creating an extremely unimportant piece of perfection. It has its own rather strict requirement of discipline.

What the Lichfield team can achieve will never be serious perfection: if you wanted that you'd hope to have Rembrandt on the payroll. And time. And not to be doing a calendar. A calendar has to be easy on the eye: there is no room for distress in it. In a perfectly ordinary but important way, there cannot be art

without the realities of life intruding quite strikingly. The Unipart Calendar is a frivolous dreamland, and that's all. Nothing wrong in that, of course.

Patrick is taking a video of the scene of our work and play. Lunch suddenly made rather a good piece of filming. We have it with our host, this ex-playboy millionaire who is now as disciplined as any other working person, but who has had the crucial – if luxurious – task of having to learn discipline for no better reason than that the soul requires it, there being no functional necessity for it in his life.

He dispenses largesse with quiet pleasure. An immense gin here, a cool white wine here. He plies the route between his bar and the various outposts of our party with great courtesy. In the video scene which I believe will be worth watching later, he listens to the ribaldries and badinage, spotted through a couple of his bottles and framed by them. His eyes move like a Wimbledon crowd's: a little smile is on his face. We are not merely a crowd with some very very lovely women amongst us, we are a pretty lively crew, as well.

22 June

THE RAP

We are into our third day of work. The team is settling down. We've seen some places which look possible: going off from the hotel in groups of three or four before breakfast to see various spots.

As a group, we seem to be finding our own language: that's the habit of groups everywhere. Rock and Jazz bands are famous for it. We are dealing increasingly in code, and this has its own dangers. Those of us who have been ploughing furrows for a while know all sorts of jargon from America and Brixton, from the Sixties and Seventies, and from movies. The girls are sometimes a bit left behind as we rabbit away. Giving it a lot of rabbit, we say: and the girls blink back incomprehension. Going for the burn, we cry: we've been listening to Jane Fonda's spiel, though there is beginning to be slightly less enthusiasm for actually torturing our bodies with it.

Chloe has become Matron. This is because she is so English and ageless and sexy. She has to be Matron because we all fancy her rotten and yet she is somehow off limits.

The models we have, disgracefully, christened as The Crumpet . . . and then in subdivisions of the genera. Melissa is, of course, Senior Crumpet (and sometimes Head Girl), whilst Gina is Junior Crumpet, on account of being eighteen. Debbie has displayed a minor but excellent capacity for talking dirty (something to do with a very direct, sexual and imaginative way of describing what Gina might notionally have been doing in a snap where she's lying on a table with the Devil clearly thinking about finding work for her idle hand). So she has to be Farmyard Crumpet.

Sebastian Keep, so pukka, is Bwana. Sometimes he may be the Great White Hunter or the Headmaster. His missus, Jackie Crier, rather fancies being Headmaster's Wife, but is, we are sad to relate, stuck in a serious way with being Puff, as in Magic Dragon. She doesn't like it, and we don't blame her: but she has an occasional severity of tone which makes a look of hers something as fierce as paint stripper. On the other hand, when she lets us off our absurdities and smuttiness, we are in seventh heaven: so perhaps

Headmaster's Wife is more apt.

Noel, Lord love him, is the Goat. This is because the Aged Art Director takes too long to say and is not private enough to be proper group talk. Besides, he does have a slight quality of awkwardness which has the required goatiness. And one's told that he is not above applying a little hex here and there: he can play dirty, it's said.

The hair stylist bcomes the Crimper, and Clayton the Dabber.

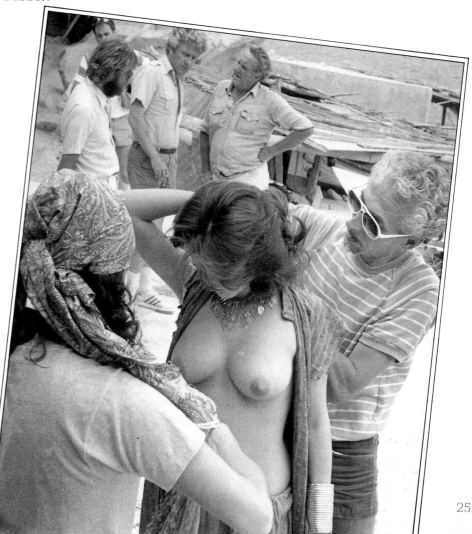

Gina may have been created more or less perfect, but even she is not so perfect that she will not receive attention from stylist, make-up man and hairdresser.

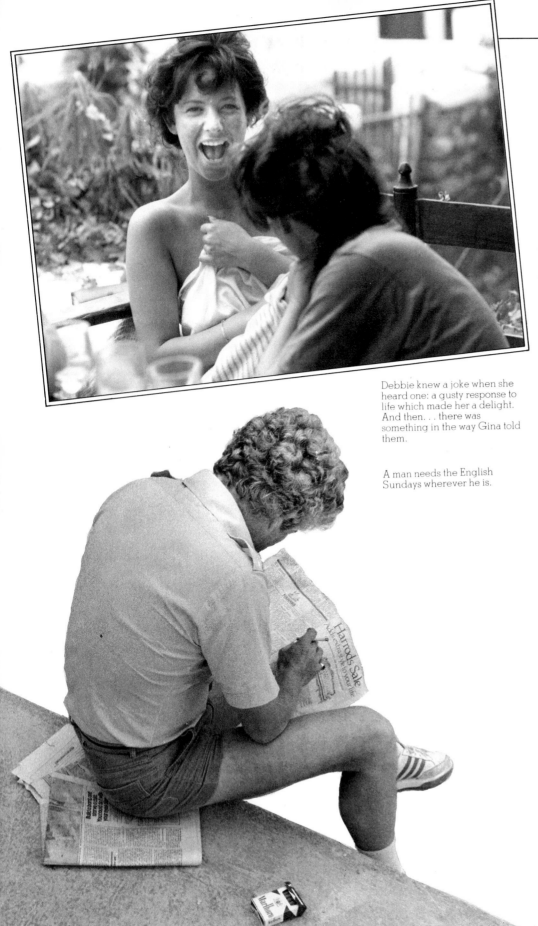

Debbie knew a joke when she heard one: a gusty response to life which made her a delight. And then. . . there was something in the way Gina told them.

A man needs the English Sundays wherever he is.

Patrick should be the Gov'nor. That's always been his name. As a newspaper writer with proper disrespect for photographers, I'm inclined to let him be nothing more grand than the Snapper, or perhaps Senior Snapper. He's a curious man, of whom I find myself getting fonder as time goes by. Reserved, in a way. Capable of great generosity and occasional stabbing unkindness. Having said a cruel thing to someone, he once told me that perhaps it didn't really matter, since he had, after all, meant it honestly: and so good would likely come. An ex-boxer, he still does forty press-ups of a morning. He will not let gourmandising, which he loves, get the better of his trimness. For all his bouffant hair-do he is proudest of all, I think, of his military time. He's fond of Sergeant Majors and the tribe and the regiment: he wears the blue-red-blue of the Grenadier Guards on all sorts of his accessories, like a woman with her Gucci insignia. His belt, his sock-tops, his camera straps are all in the uniform. It circles several pairs of white shoes which he has had made. He is flying a military flag which he has made peculiarly his own. Since he must surely be laughed at for it, it seems rather honourably ingenuous that he should parade his affection so. I cannot forbear to call him the Colonel, which he doesn't seem to mind.

And so there we all are. Some of our rapping goes a little over the top. But mostly, it is plain good fun, especially for the Scribe, to be re-writing the language slightly.

Patrick once heard an antique dealer describe the process of 'ageing' young antiques as 'distressing' them. We are in such a smart house that parts of it ought, perhaps, to be 'distressed' somewhat to suit our purposes.

By the same token, we are inclined to think that we might 'distress' some little man who was surely with us in a restaurant last night.

Alcohol has become 'the Scene Shifter', or the 'Mood Enhancer'.

Some of us have got into the habit of going off to breakfast at the Montesol, Ibiza's answer to *Les Deux Magots*, Paris's hang-out for intellectuals. It seems to be blokes only, and so we call our excursions, 'Boys' Breakfast'.

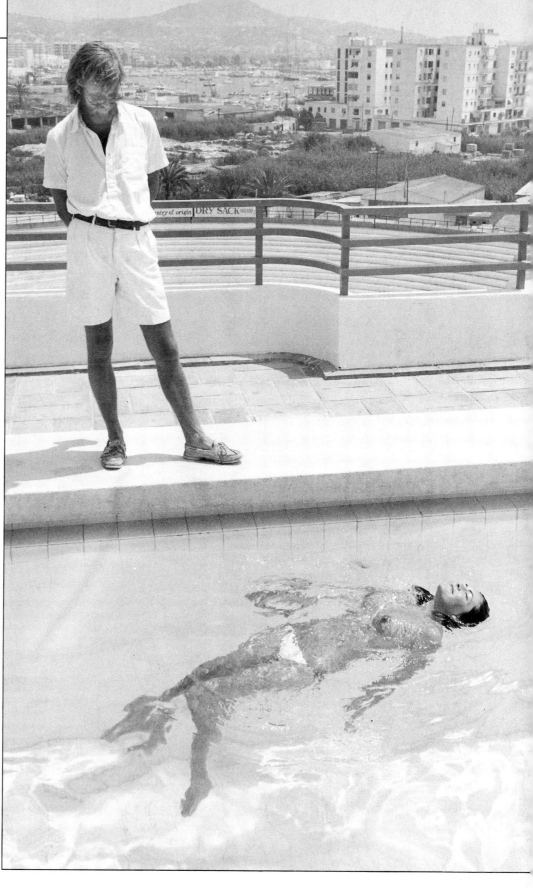

I almost forgot! The nicest of all the monikkers are the ones reserved for Chalky Whyte and Pedro Kain: they are Riff and Raff. It puts them nicely in tandem, and depends crucially on Pedro's having been in the RAF, where he learned his photography.

23 June

LUXURY

We arrive at the Rich Man's Palace for more work. But it rains and rains. A fine, insistent drizzle in an air which is heavy and sweet with released scents of the garden.

Some of us swim lazy lengths in the pool. Others do mild exercisesh The rich man is not here, and his attendants ply us with marvellous cocktails whilst keeping lunch quietly coming along.

'Sit on a happy face' is the T-shirt of the day with the cook. His small, punky assistant walks with a balletic deliberation which he must have needed a great deal of bottle to wear in his Scottish school.

Passing amongst the girls, they are like harem eunuchs, appreciated for their kindly, indifferent attentions.

Apricot juice spiked with sprigs of lemon verbena is on the table under the bougainvillea-laden porch. The rich man's minder, an ex-military policeman of dangerous heftiness and exercised bulk, mends the team's hairdryer. He does it with the air of a good-natured gorilla doing brain surgery on a fly.

The girls have nothing to do and know it. On a pair of sunken sofas which would make double beds for a rugger team of giants, Debbie and Gina are spread like panthers enjoying some feline fiesta of immense relaxation. In a grate which could accommodate a spitted ox, a fire burns, carob wood fire smells carry a homely hint across the great acres of floor. The fire is there for its scent, not its heat. The senior attendant just knows that rooms need hearts and hearths, that's all.

Sebastian doing all anyone could do when Gina takes a swim: just stand and stare.

27

CREATING THE UNIPART CALENDAR

'Where does the apricot juice come from?' I ask as he pads by, his sandals whispering on the polished tiles. 'Apricots,' he says.

Lichfield has his hair cut. He is not looking his ruggedest.

An agapanthus receives a heavy raindrop in a direct hit, and trembles on its stalk.

Sophie is doing Gina's hair. It has had hints of paprika glistered across it. 'I'd like to see your hair a bit shorter,' says Sophie. 'Shorter?' repeats Gina, incredulously, and doesn't seem that pleased. 'Well, of course, I'd never try and bully you about it,' says Sophie: 'One thing I never do about people's hair, I never bully them. They only come back crying if they don't like what you do.' She fusses at the teenage barnet with cool, delicate attention. What could be nicer than being hairdressed? A person working away at a bit of one one can't see, close to one, massaging and flicking and preening and flattering. No wonder sen sensible animals spend a great deal of time on mutual nit-picking: it is a lovely form of contact, having its own rules and requirements. No wonder women love hairdressers better than anyone.

Unless, that is, they are lucky enough to have a make-up man of their own, or even shared. Clayton Howard is, of course, something very special in this department: he is one of the most creative of the creative make-up artists. The girls love him. They love the attention and the power of projection that his gilding brings to their lilies.

About midday, the senior attendant padded out to the verandah and poured two or three bottles of champagne into the apricot juice with the lemon verbena in it.

The cloud maintains its holding pattern in the sky for most of the day, but eases off late in the afternoon.

The carob log on the fire has nearly burnt itself out. The girls haul themselves back from their langorous colloquies and into a working frame of mind.

The shots are piling up now. Work has been flowing with an almost monotonous efficiency. The group is visibly gaining in confidence.

24 June

THE BOTTOM LINE

Noel Myers is building up for his annual binge of serious introspection. He is in the position of having a pile of Polaroids, which give him an idea of the overall content of the Calendar. Patrick and he are often to be found with their heads together, making sure they are in tune.

Patrick sitting under a carob at a table: he is dealing himself the sixteen shots which it is agreed are acceptable to be offered to the Client. He looks like a man playing patience.

I.had remarked, in one of what are becoming too many moments of supper time loose-tonguedness, that whatever else it might be, the Unipart Calendar was no Rembrandt. Tut tut. Noel says how seriously they take the work. 'It is extraordinarily pretty,' I say, helpfully. 'I hate that word,' says Noel glumly.

'Mind you,' he says, 'I know what we do doesn't help the starving of the world.' We are in a quest for the Bottom Line. The point of it all. I try to persuade him that it's perfectly honourable to put a lot of sweat into making the garages of the country more attractive places. He still thinks I underestimate the serious lovelines of the enterprise.

'I want to wear a few more clothes,' says Gina, plaintively over lunch. (We are in one of the dozens of beach restaurants: every day a new one for lunch; every night a new, starry-skied terrace for dinner.) 'Patrick said I could wear that skirt.' 'I shouldn't count on it,' says Jackie just a little wearily. She has been on this road before.

'What a silly way to wear a chain,' says Clayton, as we drive along. He's looked out of the window and seen a cow under a tree on a rusty lead.

At dinner, Noel throws me a long, steady look, his head shaking slowly, incredulously, from side to side. He has discovered a philistine who dares to think that one of the reasons why the Calendar is acceptable to all genders and classes is that it is in some curious way eunuched. It sends itself up, for a start. And it is contrived to please the fantastical rather than the erotic part of our minds.

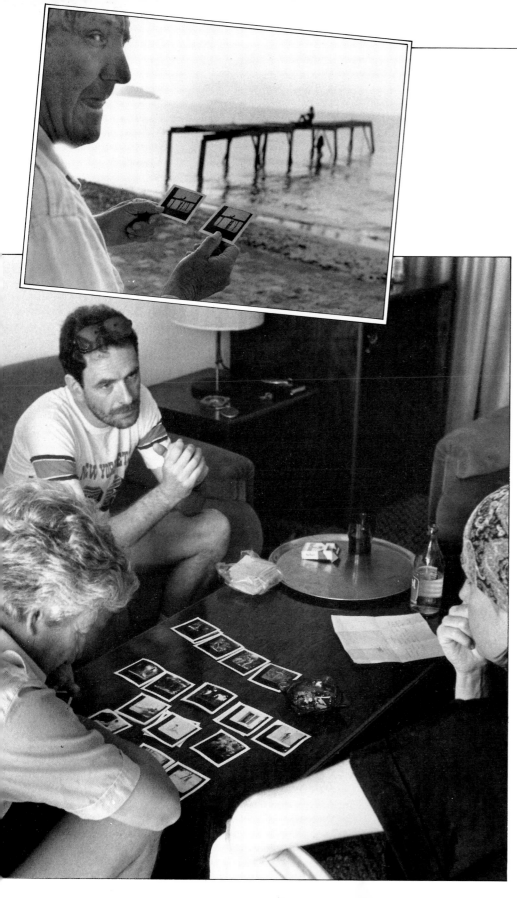

Below left
The story so far. Patrick, Noel,
Pedro, and Jackie take stock.
The Polaroids are all they have.

Above left
'Orlright then, which one will it
be?' The art director on the
horns of a dilemma.

Noel is still in search of the Bottom Line: a feeling man, he cannot but find it incongruous that a team of ten or eleven people are devoting themselves to such a potty, concentrated, hilarious, expensive business. He thinks it is justified by sometimes producing a very beautiful picture. I think it is justified by cheering people up on dreary winter days.

Noel now has enough snaps to play with to be of the view that decisions must be taken. If he goes on allowing the Calendar to proceed along current visual ideas, within a day or two he will be seriously committed to it. It will be hard to take off in another direction and do justice to it, unless we make the change now.

During dinner, Noel will sometimes get up and go for a walk. He is thinking things through. There could be very serious meetings and confrontations and consequences if, in the excitement of working hard, the team actually didn't see some obvious defect in the Calendar's style. Tens of thousands of pounds are on the line, and Noel has ultimate responsibility for making sure that the couple of dozen shots we're doing are coherent. He must see the wood for the trees, at all costs.

25 June

THE ROW

Gina in the car: 'I really like Debbie. She's my friend.'

The group's really on song now, said someone.

'Don't laugh,' snaps Noel at the Scribe, whilst a certain amount of ribaldry has been going in one of the lulls in the preparation of the shot.

Clayton fusses at the model: moving a strategic shawl, or helping the re-arrangement of an awkwardly lying breast. This is his unique extra-mural role.

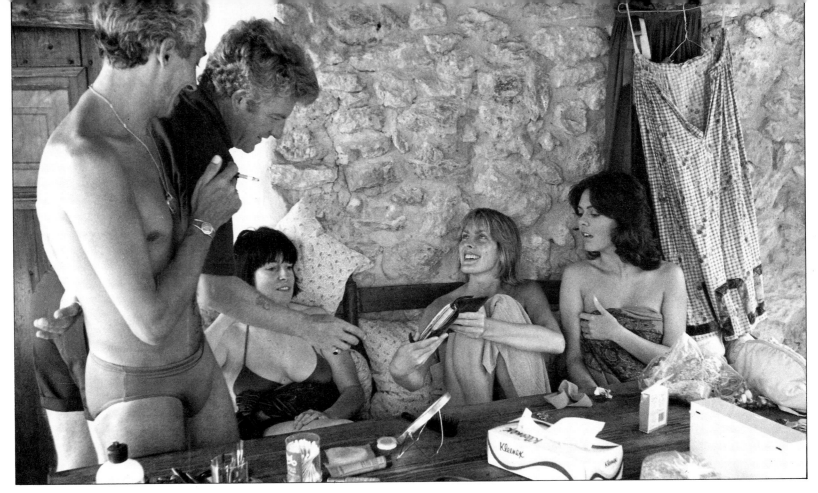

Lichfield proving what a popular fellow he is, in the make-up corner, with the thickest portable address book in the world.

The laugh was a small one and it was stifled. Myers comes up in a minute or two and says, 'Look, don't worry: I wanted to make somebody the scapegoat, to get the point across that this is a serious business. You just copped it because I thought you could take it.'

The group sense of humour has indeed been galloping away, and some of us needed taming.

'I don't know,' says Noel, of a shot in which Melissa is a lissome introduction of beiges and ochres on the ladder leaning against a carob with a tree house in it. 'I can't say I get any feeling out of it.' 'I'm going to do it anyway,' says Lichfield. 'I think there's a shot here, even if I am the only person that does: and that's happened before.' 'You're the Guv'nor, Guv'nor.'

We have moved to another Rich Man's House: this one is up a bouncing track and is smaller, more primitive and authentic than the first. It has beautiful terraces which are used as rooms.

Debbie is deployed against rich bolsters and pillows: a Moorish extravagance is in the air.

Gina is exposed at a window with faded woodwork: I'm putting private money on its being one of the shots we will remember.

The place is dictating pictures in its own right.

The woodwork in one shot looks almost too new: 'Rub it down with tea bags,' says Myers in a peculiarly English response to the problem.

It has become clear that the rough-and-ready ways of a street-hardened old hack from London town may well not suit the tenor of this party: I make a decision to tone things down rather dramatically.

We repair to the best restaurant we've found, La Posada, in the lee of the lovely sharp hill of Santa Eulalia, with its perfection of a white church. I make a pre-dinner sortie to the church just as the village is gathering for a funeral: a peculiarly sweet solemnity is in the air.

At dinner, in a mood of very nearly perfect cheerfulness, I declare myself extraordinarily happy. Within minutes Sebastian has filled my dinner plate with an upturned glass of wine and is lacerating me for being loud, intrusive, assertive and obscene. Ooops.

Clearly this business of being in a group is quite as complicated as Lichfield and Sebastian and the others have always stressed that it can be. Someone usually gets the most amazing roasting from someone else on these forays: deserved or not, or a bit of both, I've drawn the short straw.

Ah, well: apparently it's all to do with the required chemistry of the annual event. Frankly, I feel as though I could take all this drama, or leave it. Actually, I'd rather leave it.

26 June

IBIZA TIME

Ibiza's clocks are set an hour ahead of London's. You wouldn't know it: there are people here for whom time has been stopped for a decade or more.

Sebastian cannot get anyone to do anything before eleven in the morning, except for us lot, of course. In being active by eight, we are unique amongst the paradisical crew who lounge their lives away here.

We repair to La Villa, one of the island's most lush watering places. Everyone and his wife is out on the town: an artist here, a remittance man there: a glowing, tedious gallery of all the best that the Sixties matured all over Europe. I am learning heartily to loathe this place: the locals are fine, and the tourists are at least jolly. But most of the expatriates are very peculiar. Perhaps I just disadmire their ability to live away from Home, which is where my thoughts keep wandering.

And then Matron and two of her friends, sitting in a row in the moonglow, under a oleander. Blonde, suntanned, laughter-lined, all in pink with the same bronzed shoulders. The Three Sisters. All is forgiven. For now.

We are on Ibiza time. Lunch is a two or half past affair, dinner's at nine or later. If it were not for the models' requirement for sleep, we would burn the midnight oil horrendously.

27 June

THE DAY AT THE SEASIDE

The days are now gathering to themselves a kind of perfection.

We take off to the seaside at the north of the island: the huge geological features, great cliffs and ravines are useless for our purpose, so we go to a fishing bay where the double-prowed boats are hauled up on tree-branch slipways.

'Bit Polperro,' says Lichfield, a trifle worried. He needn't be: the place is rich in clues of the exotic, almost north African influences. The steps carved out of sandstone, a quality of heat that makes the huge

rollers seem to have arrived fresh from the Pacific rather than from any chilly Atlantic near Britain.

Three shots again fall into the hand like sun-warmed plums from the tree.

Melissa looks the superb big sister to Gina in one shot.

Another loud dinner, but things are *much* more under control. We play I Am a Famous Person, and a hideous thing involving trying to catch a train.

Melissa is troop leader in the games department: somebody could make a useful Duchess out of her.

Gina clocks some repose. The baby of the party, she was blessed with a look of innocence that would unbend the sternest soul.

28 June

REALITY INTRUDES

Seven o'clock Tuesday. I come downstairs and see Sebastian with two policemen. Guns at the side: proper, dodgy policemen. A minute but definite flick of the hand, directed at me and shielded from the fuzz, tells me to disappear myself. I hit the street with nary a Good Day.

In the local café, where street sweepers and dustmen and other early birds are out dishing the dirty and getting the sting of a liqueur in them for the rest of their shifts, I begin to speculate about that near miss I had on the road the other night, when I forgot which side of the road I was supposed to be on.

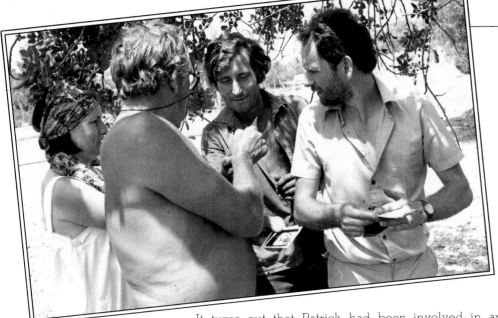

The sheep-owning farmer giving Noel and Pedro a little advice on what really looks good in this countryside; he was a very likeable fellow.

It turns out that Patrick had been involved in an accident. 'A minor hiccup,' is how Sebastian describes it, deploying *sang froid*, aplomb, understatement and stiff upper lip as though these – an Englishman's greatest prize – were going out of fashion.

Patrick had been out to the Rich Man's House, to placate them about our having borrowed a car for a day longer than we had intended. Coming home, the accident. He is lying upstairs in his room, having discharged himself from hospital, preferring his own bed. There is another person involved: a man with a broken arm, in the other car.

The team goes into a state of considerable shock. The Man is in his bed, nursing busted teeth and a bruised shoulder, on which the name of the seat belt maker who saved his life is apparently emblazoned.

A day off is declared, and I retire to a convenient beach to let developments develop, sure in the knowledge that whatever else happens this day, it won't be pictures for the Calendar.

Sun, sea, and sand for some of us. Bruises and sedatives and an inundation of pressmen from London for others. Patrick is declared to be quite his old self at lunch that day: Sebbers is not the only merchant round here with a stiff upper lip in stock. Lichfield's is also rather badly split.

On the beach there are all sorts: good old biddies and beautiful youngsters. Many well-preserved grannies enjoying the unexpected exposure of their keep-fit bodies. A woman lying next to me takes off her caliper and a friend helps her sleepy leg into a convenient position. Creation has fashioned an extraordinary variety of bodies, and life leads them into all sorts of conditions: many of them are beautiful. The hunt for perfection is a debilitating one. The girls we lovingly photograph have great loveliness and are nice: but there is no scoring system for the pleasure we take in each other's bodies: it should depend on affection, not perfection. Increasingly, the men in the party, I think,

are of a mind that we are not as in love with The Perfect Body as the marketing men of sensuality would have us believe.

Or, to put it more simply: there is no accounting for taste.

29 June

THE GHOST IN THE MACHINE

The men from the *Mail* are downstairs. The blokes from the *Express* are camped out in another hotel. The *Mail* is staking out the foyer, making sure that no one can get in or out without their knowing, though of course Patrick Fitz-Gibbon, the Unipart PR, who has arrived post-haste from England, and is now making sure the press sings from the official hymn sheet, knows where the service lifts are. There is still no indication as to what the other man in the accident is saying, nor which way the police will bounce. They have Patrick's passport, and the entire situation is therefore more than a little sweaty, with very little way of predicting the outcome.

But the shoot must go on, it is decided.

We are going at it mob-handed. Chalky and Pedro are going to be in their element, and stand a serious chance of coming into their own. They know Patrick's ways and wants of old, and they know the pictures the team knows how to do and does best.

We go to the locations that have already been thought through, and the team works the trusted formulas, knowing the questions Patrick would want answered if he were there, indeed knowing them so well that had he been there most of them would have been answered even before he got round to asking them.

Pedro's manner at the camera is considerably quieter than Patrick's, partly – in one shot – because Gina is sitting under a tree with sheep grazing: they mustn't be disturbed. But Pedro's whispers travel through the air like radio signals, and Gina's response to them is precisely accurate. She has extraordinary patience and compliance.

Looking down into the Hasselblad's viewfinder, one's gaze is met by hers: it is direct and almost passionate.

These girls all have a very private and intense affair with the lens. They conduct their relations with it with perfect aplomb.

Noel and Jackie play a stronger role now: they are more truly the custodians of the look of the thing than when Patrick is around and they proffer their views less tentatively.

The shots turn out to be extraordinarily good.

Amongst many other blessings surrounding a potentially dreadful accident was its timing: there would have been enough shots even if work had had to be called off. As it is, mopping up these last few allows more choice.

30 June

TECHNO-RAP

While we've been taking shots, the Snapper, aka the Colonel and the Guv'nor, has been lying in bed, and occasionally making forays to the dining table to prove to the world that there's life even after near-miss car crashes.

'I have spent a great deal of time in communion with my Maker,' he says through broken teeth.

Something or other went well. The police have decided that neither Patrick nor the other man – he of the broken arm – was to blame for the crash. Passports are returned and the file closed.

The girls line up on the steps of the hotel as the old soldier, with at least some of his former *élan*, climbs into the taxi which is taking him to the airport. 'All I want for Christmas is . . . my three front teeth,' they chorus and the Lichfield mouth, which looks as though it has been French kissed by a Mack truck (to quote the country and western jokester, Ronnie Prophet) hoists a tattered grin.

George Hughes, a photographic newspaper editor, has been with us a couple of days. Whilst I hold a complex array of filters and diffusers over the lens of the Hasselblad for Pedro, he asks serious questions about batch colour casts and FX9's or something. My mind wanders away from such serious talk. All I know

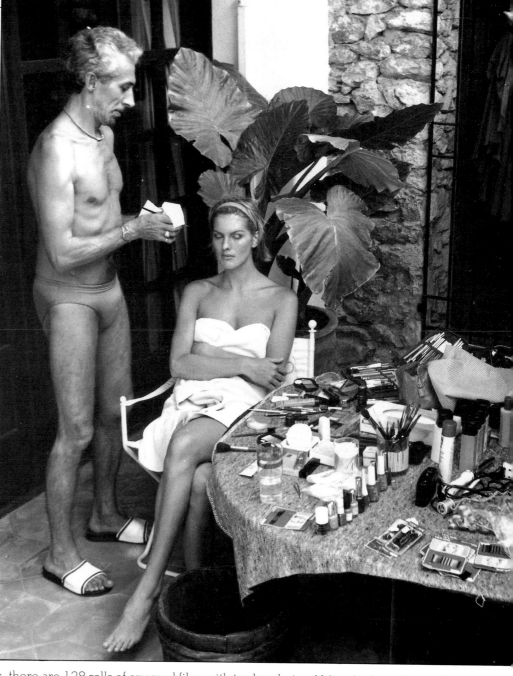

is, there are 128 rolls of exposed film, with twelve shots per roll. At a tenner a roll for processing, these holiday snaps are coming in rather dear.

I come to gently, to hear Chalky tell George that he's been running 10Y on much of this shoot, because of the colour balance. My mind wanders off again.

Melissa has been working with the crew down on the saltflats by the airport. The shots look very picturesque, let's hope the punters don't spot the mosquito-haze humming in the foreground. Melissa is far too stoical to complain, though she's not best pleased when an army of ants get to work on her right foot.

Melissa, her face so fine it looks as though it could only belong to some wonderful Ethiopian, receiving the special treatment from Clayton. A curiously 'harem' atmosphere hung over the make-up department throughout.

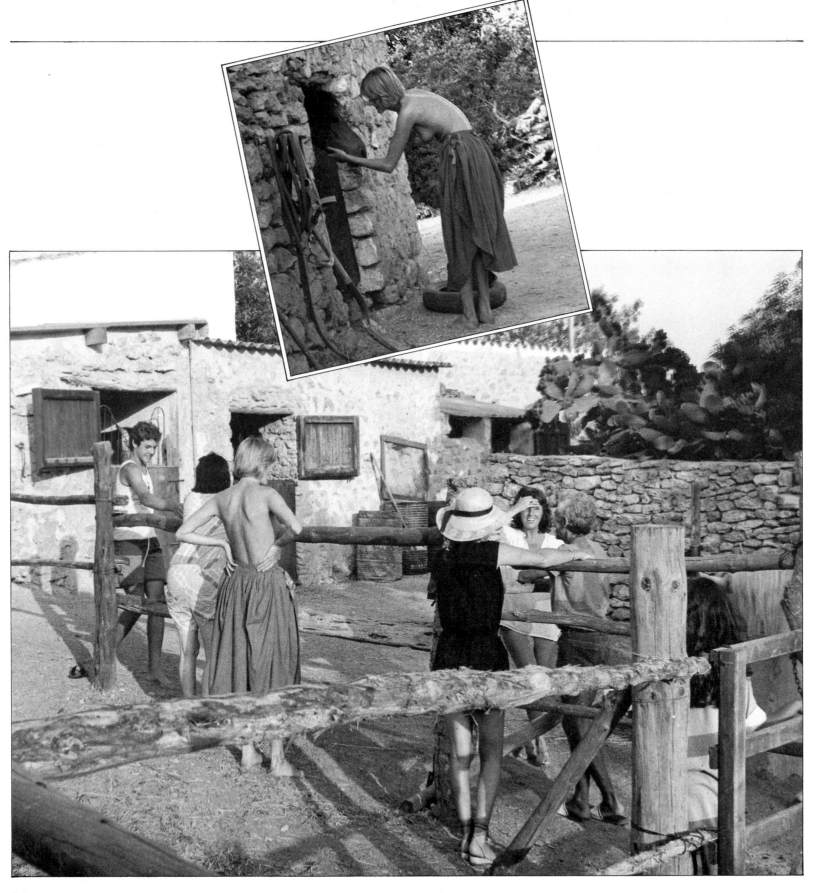

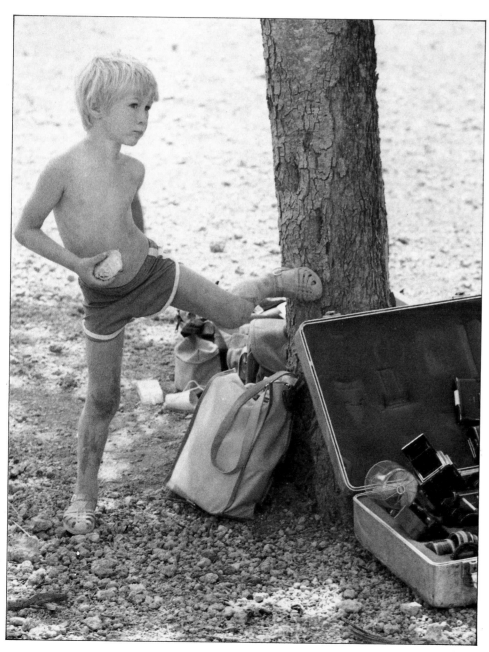

1 July

THE LAST DAY OF WORK

Without Lichfield around the days seem oddly flat. The team is doing stalwart work for all that: while I go shopping for the kids back home, they snatch more pictures from the jaws of opportunity. The jetty picture had been planned all along, and was soon in the hand. If the Lichfield team haven't worked out back-lighting by now, they never will. This time, they're laying it on with a trowel.

Melissa makes sure the horse picture gets down: amazing on a horse, says Noel. Just seems to know how to make the animal do everything right, and first time.

3 July

HOMECOMING

415 kilos of luggage give Sebastian Keep one more fright, as the guys at the airport decide to awkward it up for a while. Finally, we're through. Just another bunch of English about to go home. Ibiza has done its work for our fellow travellers. Those that arrive tanned go back blackened. Those that came white go back variously pink through bronze. The same policemen seem to be gathered round the bar as were there when we arrived a fortnight ago. A fortnight? A lifetime.

Sebastian leaves us: he's going round the island making our thank yous.

Far left
Melissa establishes rapport with the horse, for a gorgeous shot which doesn't see the light of day.

Left
Small peasant boy and classy camera gear.

CREATING THE UNIPART CALENDAR

12 July

ENVOI: LONDON

It felt peculiar to see the old gang again. Sebastian, as cool as ever, scheming schemes about the Far East for yet another Lichfield assignment. Pedro at the projector, showing the gentlemen from Unipart the proposed shots for the 1984 Calendar, with Noel (as ebullient and tongue-tied but loquacious as ever) and Lichfield (teeth restored to order, the old face put to rights, the lip healed): all of them grouped in the cool gloom in front of a white sheet which blew slightly in the very small breeze that they had somehow engineered in the heat of one of London's hottest-ever days.

Downstairs, a sheet of paper lists the Lichfield day: appointments every hour or half hour, all of them over-run, all of them pressing. At the end of the day: 'Dinner at flat.' In a couple of days, he's off again, on an extended recce for a job he very much wants. His Duchess, Leonora, will have to put up with another few weeks of his absence. It makes you wonder what makes men like Lichfield run, and run, and run. Being his own man, I suppose. I'd rather sell the Merc than be in a flat spin paying for it. Still, it takes all sorts. I wouldn't be a bit surprised if he didn't have some hard talking to do during 'Dinner at flat' to persuade his better half that all these absences were really worth the strain they must impose.

Noel told me one day on Ibiza that he always forgot the rows and the hassle from one year to the next. Probably any one of us, if asked, would go on another Unipart shoot. If only to see who gets the short straw next time.

The pictures flash by on the screen: hundreds of them. A kind of democracy is at work: each man selects his own 'worst' out of a batch and gradually a kind of agreement accretes.

Chalky is downstairs, flicking through the black and white pictures he shot for this book. Pedro is just back from doing a high-powered shoot in his own right. Felicity, den mother to the studio, is fielding calls. Percy, Lichfield's all-purpose 'man' – part minder, part confidant, part valet – checks in to see if there's anything he can do. One wonders again about how

teams get formed, and what odd chemistry keeps them humming. Certainly, Lichfield's Unipart gang are about as oddly-assorted as you'll find. Presumably that's why we're all still interested in it, in spite of knowing that taking snaps of young ladies is in most sorts of ways an odd way for grown men to spend a fortnight or so every year.

Lichfield may be repaired physically after his car crash, but we do wonder if he has quite let in the full shock of the event. He may infuriate us at times, but we still all feel quite a lot of concern for the man. And realize also that if there's one thing we know about him it is that he won't be told. Obstinate beggar: that's his bottom line, I do believe.

Noel and Melissa take one last look at paradise. Probably, Papillon himself was never so glad to see the back of an island.

Opposite
Watch this space. Patrick and Noel discuss the pictures in the studio before a presentation to Unipart.

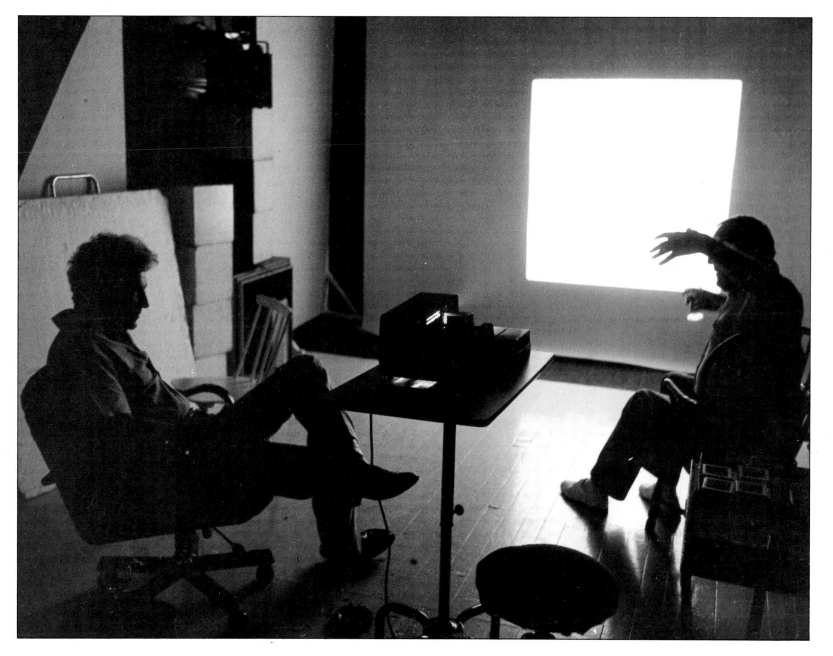

This is the picture for me: the pre-Raphaelites were about equally hung up on love and death, and their favourite model was a dark-haired, rather stern-looking girl – the daughter of a groom – who led the Rosetti crew a terrible dance, if I remember right, and OD-ed one laudanum on day. Sally plays the part to perfection, with a little help from filters and stuff which gave the entire snap an alabaster cool. There is light being bounced around in every possible direction. . . but what matters is the eccentric talent to decide to play such a wonderful game with images of death and the sepulchre. . . very saucy.

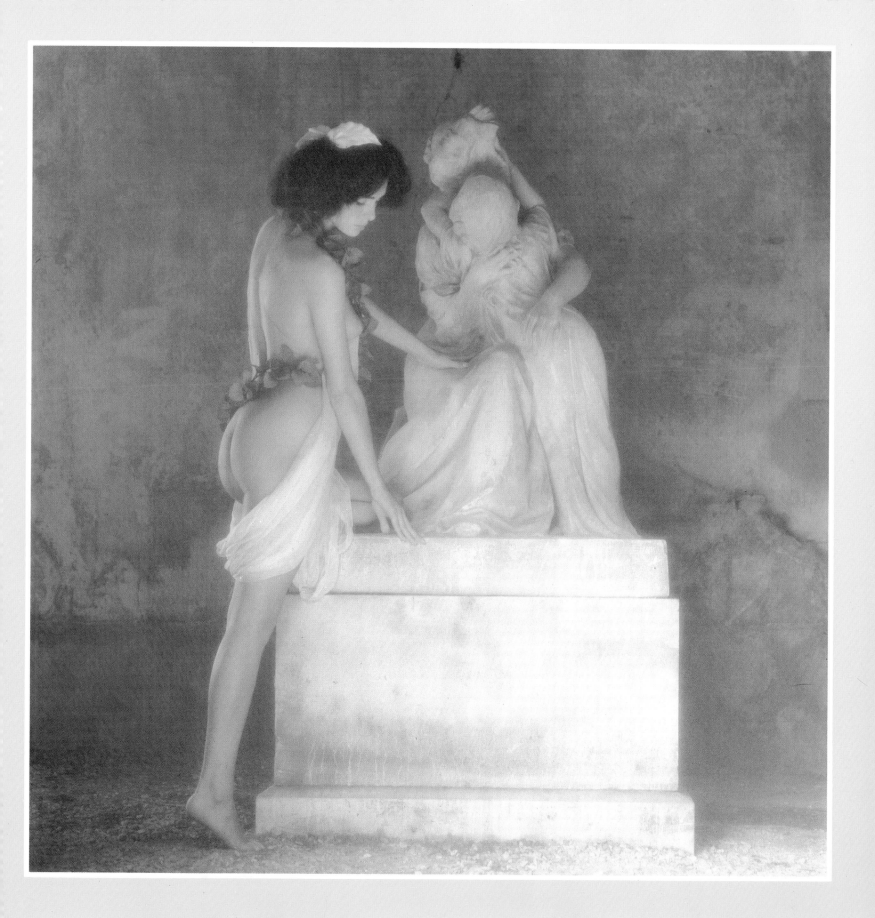

'Now see here, you little baggage,' says Niké, 'I know it's been a long day, what with the funeral and everything, but we're either playing strip poker or we're not. It's half a ton of emeralds to an urn-full of ashes that the feathers have got to come off, or I'm not playing any more.'

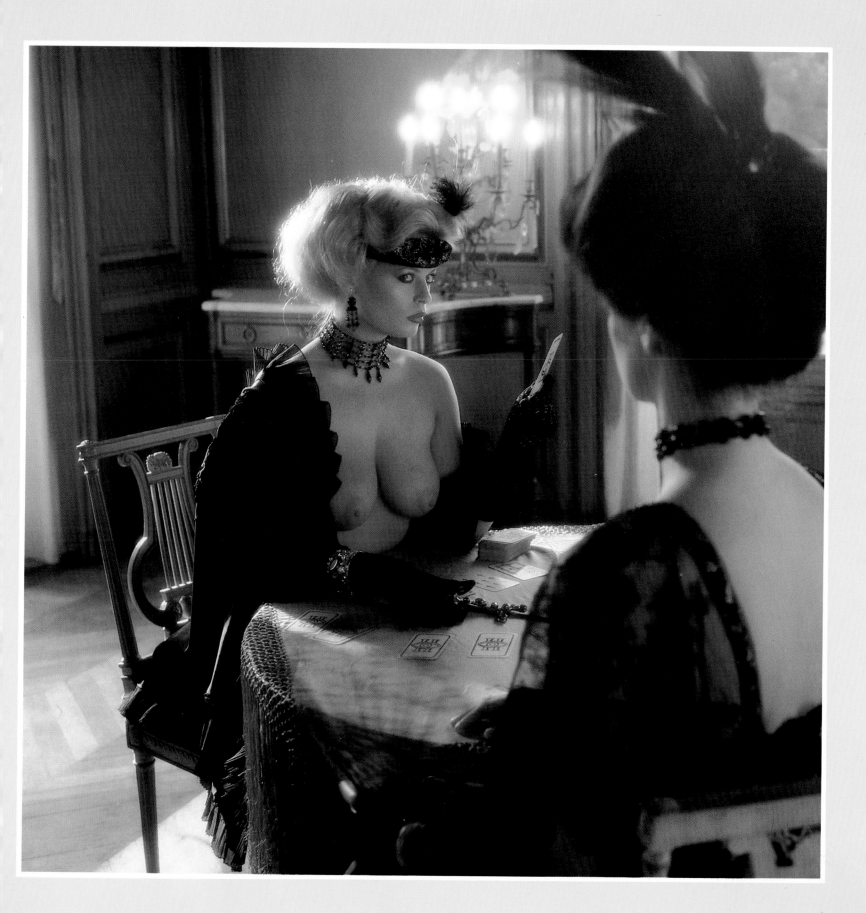

'Or ever the silver cord be loosed, or the golden bowl be broken, or the pitcher be broken at the the fountain. . .' Steady there, Debbie, one false move and all those dire prophesies (Ecclesiastes, 12: 6) might come true. From the look of her, this fantastical girl might also be reminded of other bits from the same Biblical few pages, How about 'Vanity of vanities, saith the preacher, vanity of vanities; all is vanity': butter wouldn't melt.

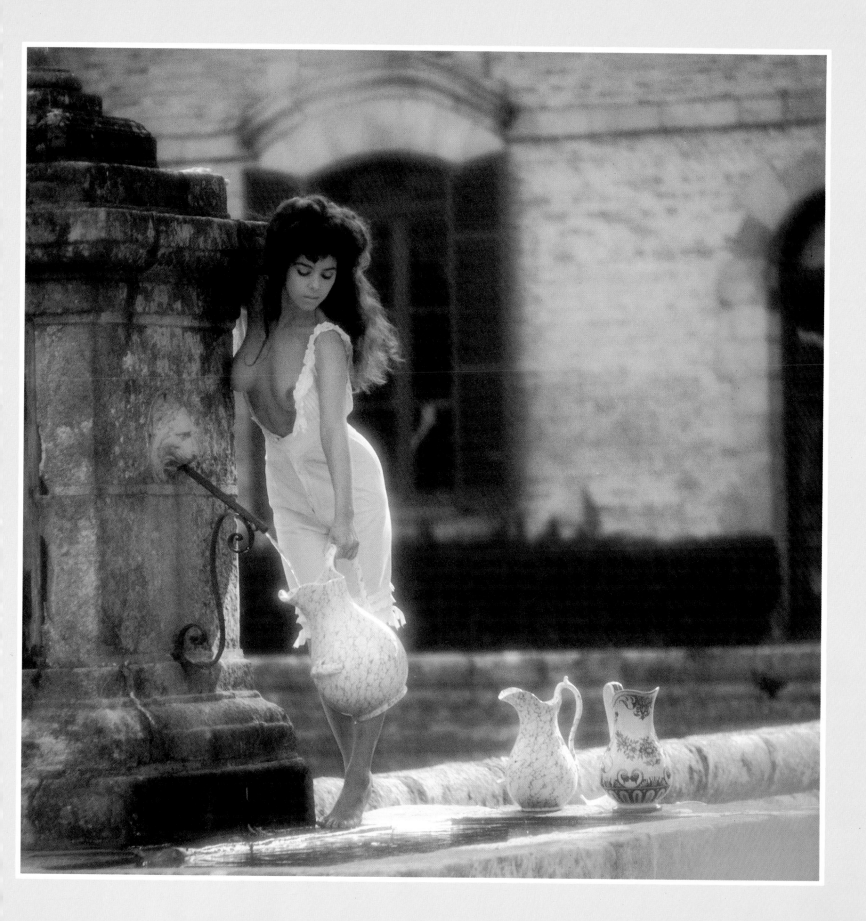

Niké, Debbie and Sally are certainly staying up late and having fun, now the grown-ups have gone out. Or are they the celebrating beneficiaries of the old boy's will?

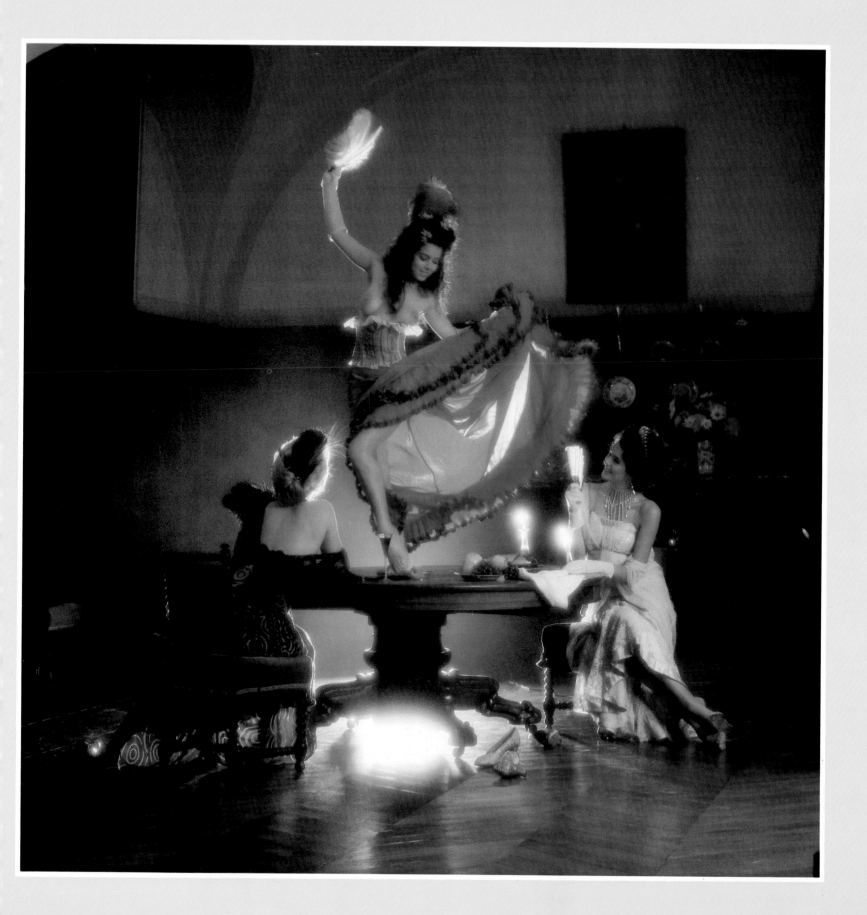

The croquet lawn's overgrown, the laundry van hasn't brought a change of clothes, there's nobody to brush our hair, and God *knows* if there's anyone in the kitchen to get lunch... meantime, though things aren't what they were, let's go and have a nice chat in the garden. No point moping, not in this vale of tears.

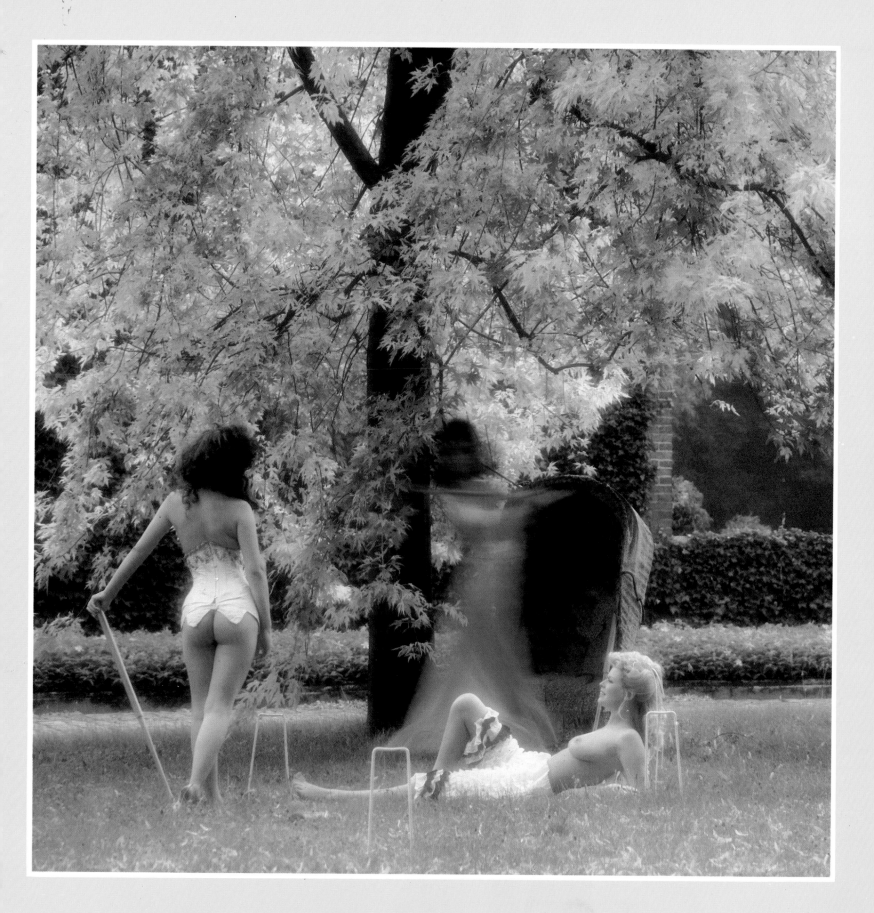

Now of course they're going to take forever if they think *this* is the way to get dressed of a morning. But it gives you a rough idea that Debbie is being prepared for an extremely dotty party. Niké is the blur in the background: she's got herself into a flat spin already, clearly.

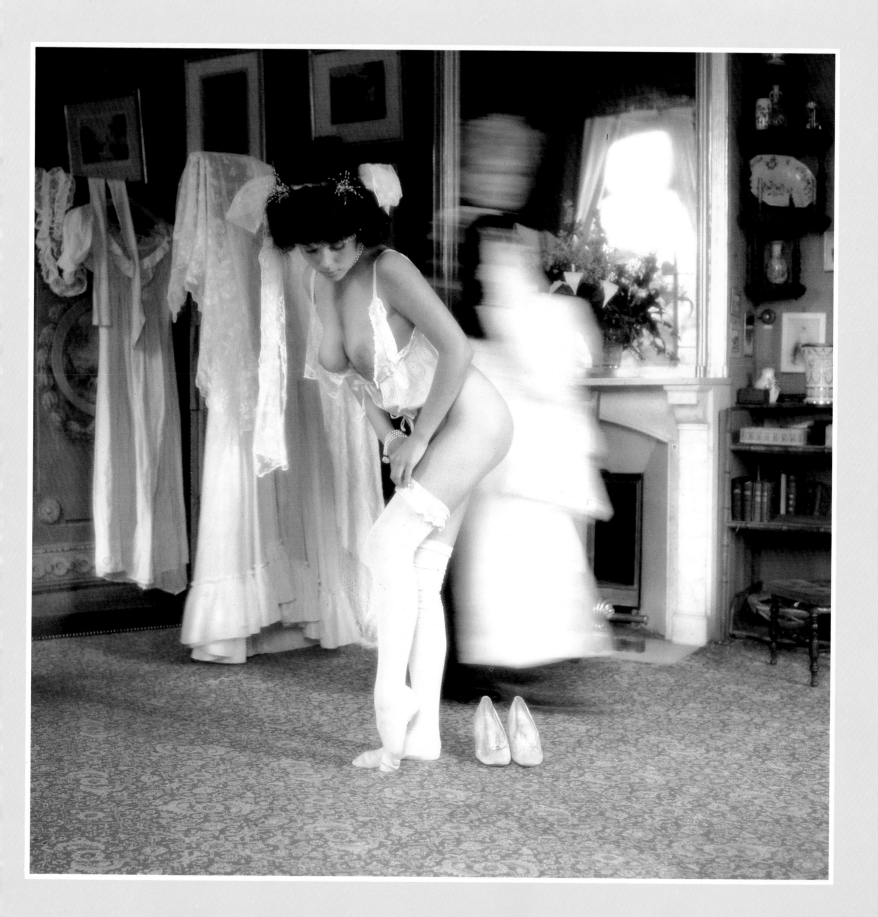

Things are going from bad to worse, in this *Belle Epoque* château. I think this girl – it's Sally – has turned up for a funeral: it's one thing to come on a horse, but on the sloppy side not to have rented a bit more mourning gear.

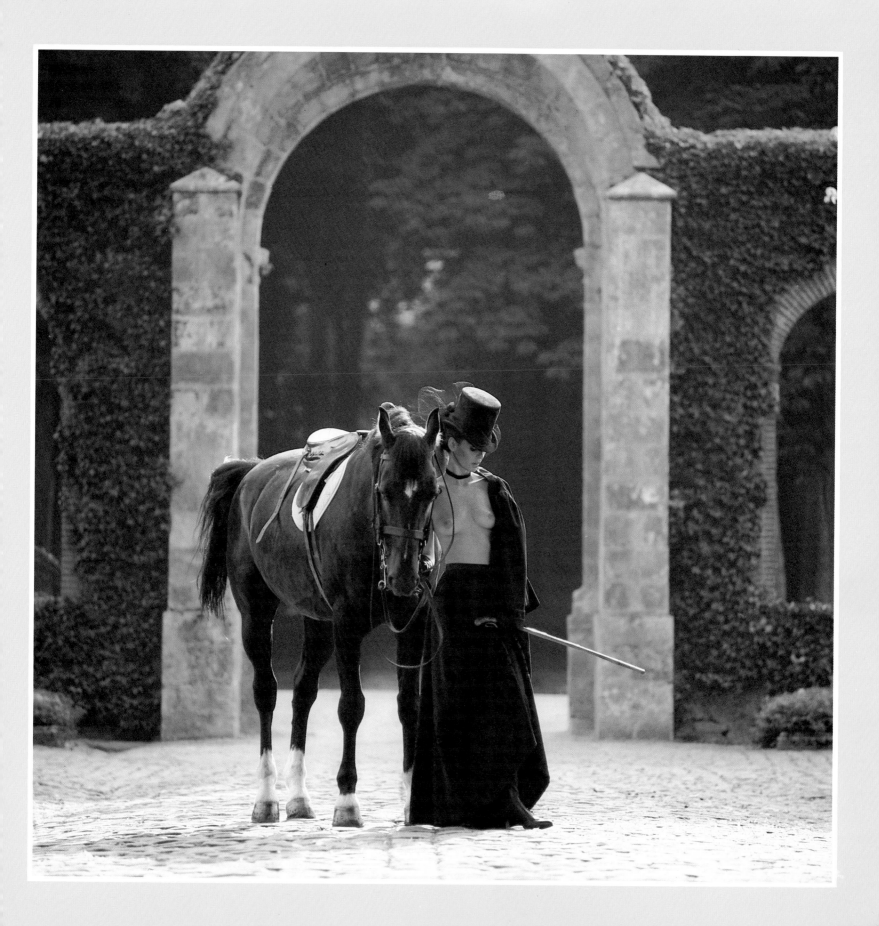

'Well, I know it's only a funeral,' says Madame Niké, nonchalantly propped against her escritoire, 'but a woman ought to look her best even so, and I don't see why I shouldn't wear the bloomers if I like.' Frankly, whoever's on the receiving end of her look would be advised to give in, or there'll be hell to pay.

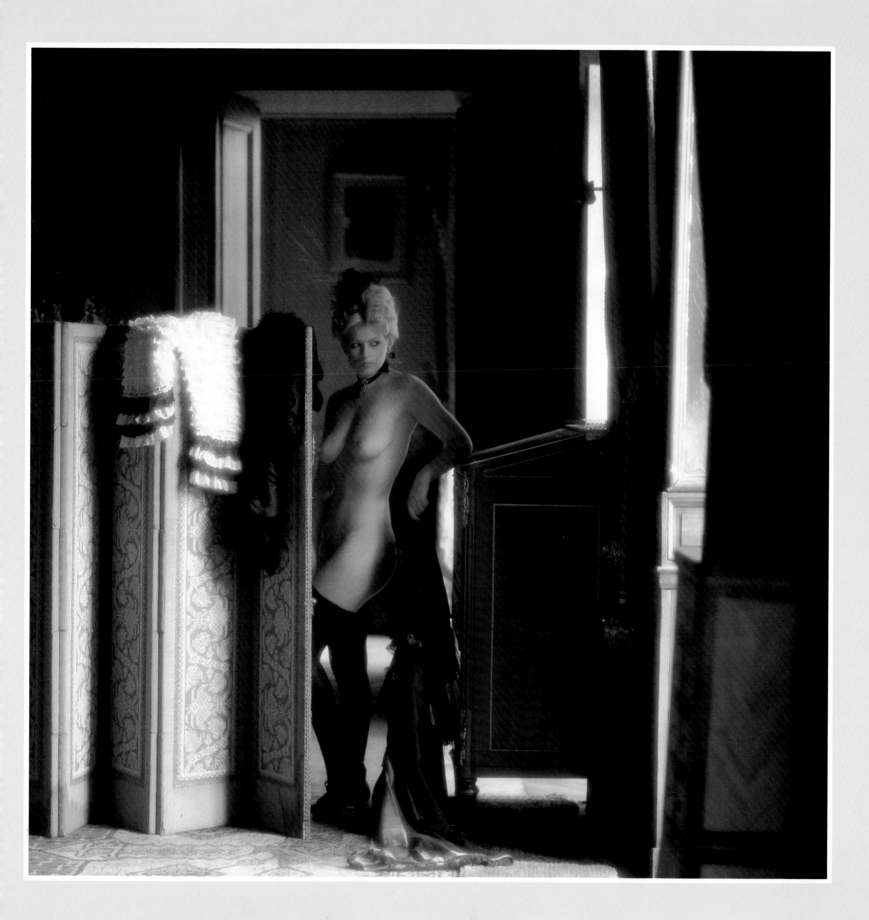

Girls lost in some world of their own: not
lesbian, as in the Sicily Calendar a few
years back, and actually somehow rather
innocent. That was the rough idea behind
the French shoot. Personally, I think the
theory that the group of girls have arrived
for the funeral of a distant cousin seems to
hold good. Here in those idle hours which
afflict the rich and make us envy them, Niké
gives the exquisitely pre-Raphaelite locks
of Debbie a good going-over.

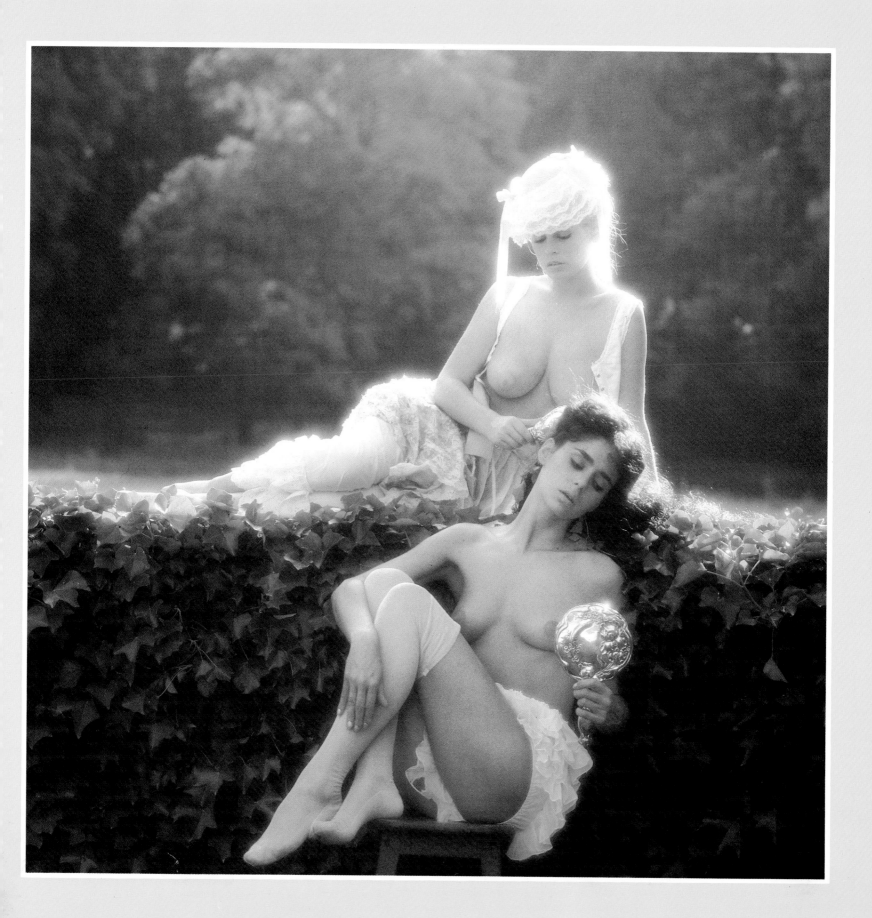

These are the sorts of moments which litter the imaginations of men everywhere: they are sweet and sexual in about equal measure. . . private, glamorous, friendly, intimate and casual. Perhaps it's the sight of women behaving in the way of children. . . the pleasing notion of tomboys with tits. Anway, enjoy (from left to right) Debbie, Sally and Niké.

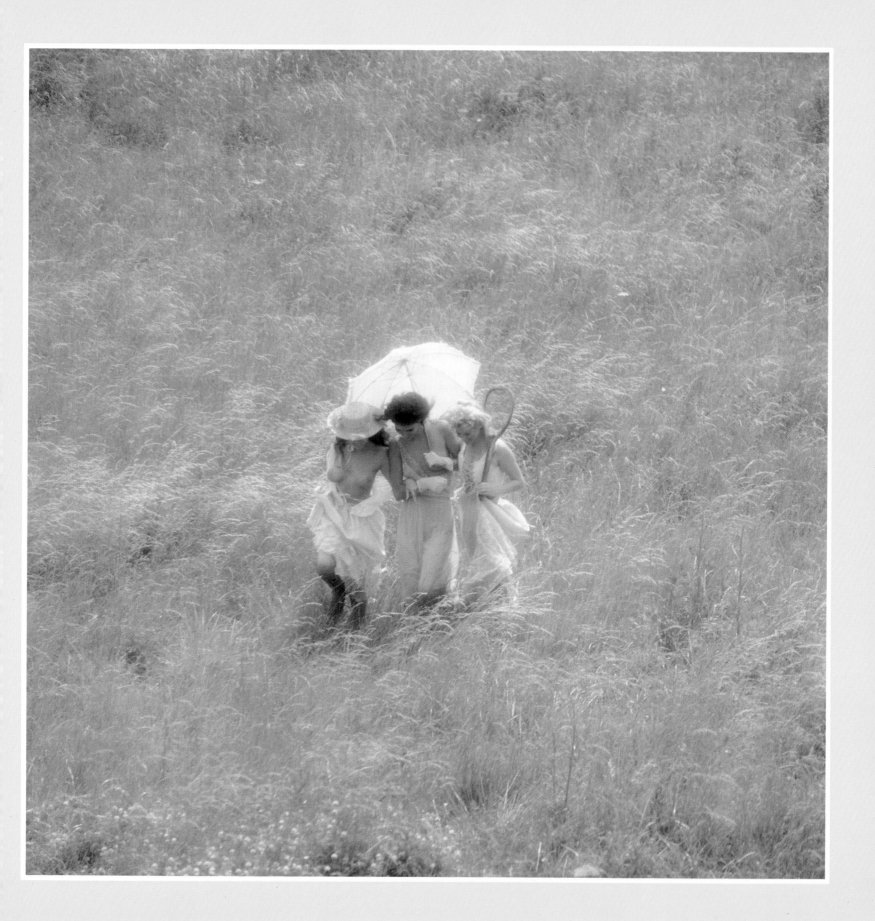

And now, thinks Sally, we've got the old boy in his grave, but when does the party really begin? This picture – all the shots for the 1983 Calendar – looks so gorgeous and plays such lovely games, it pays remarkable tribute to Jackie Crier's capacity to find exquisite schmutter, and deploy it so lovingly.

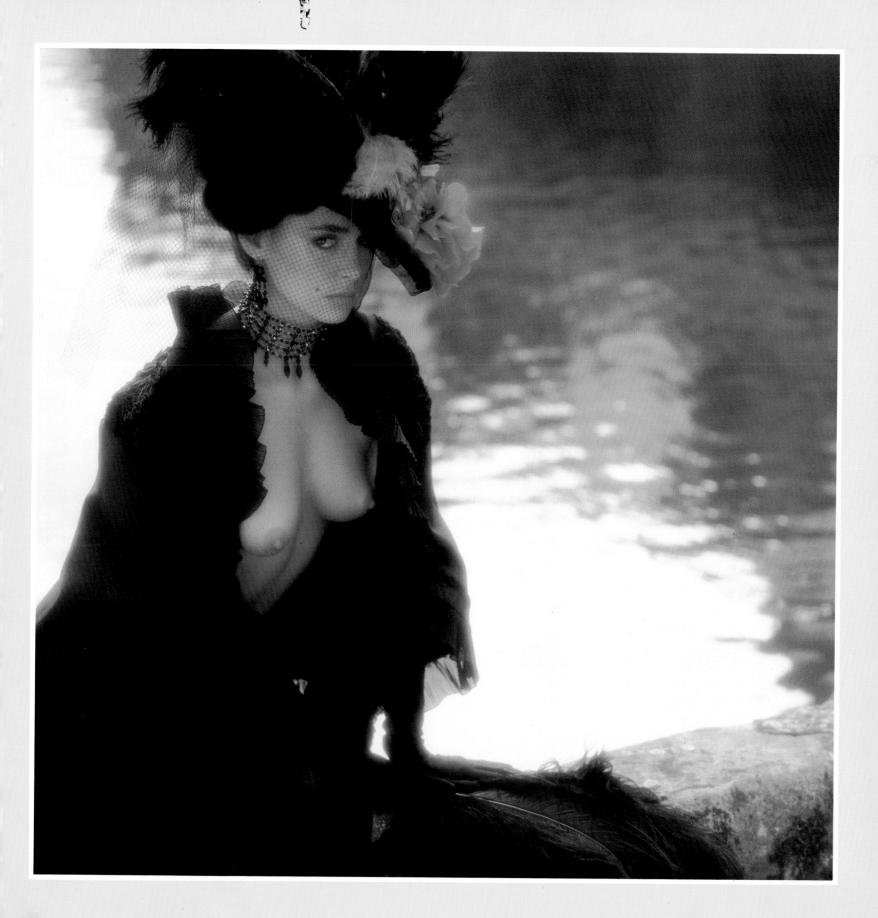

'Oh, her. . . you know what she's like once she at her floral arrangements,' says Sally to Debbie at the window. The team have pressed the château's flower-room, with its splendid cooler cupboards, into service. The mistress of the house, Niké, is clearly well stuck into her domestic role: there'll be no play yet.

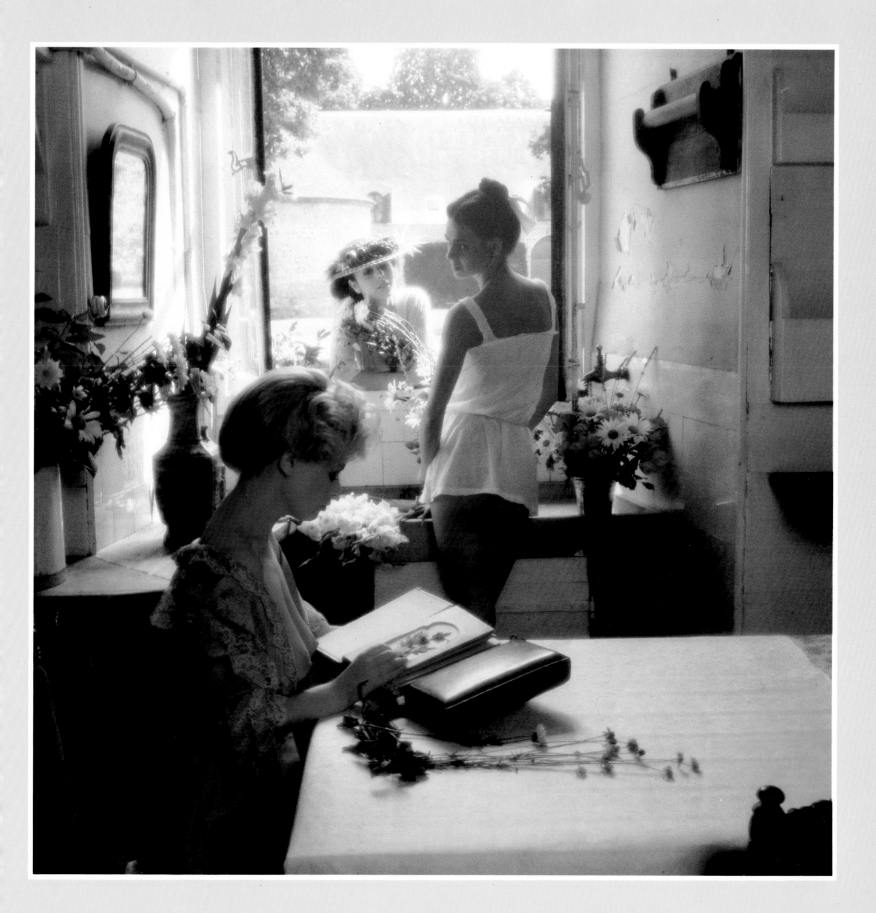

This was going to be a full-blown, Millais-
style Ophelia snap, with blooms and gloom
and what-not. Heavy stuff, *non*? Instead,
we've got Sally as a water nymph about to
have a word with the strolling Niké.

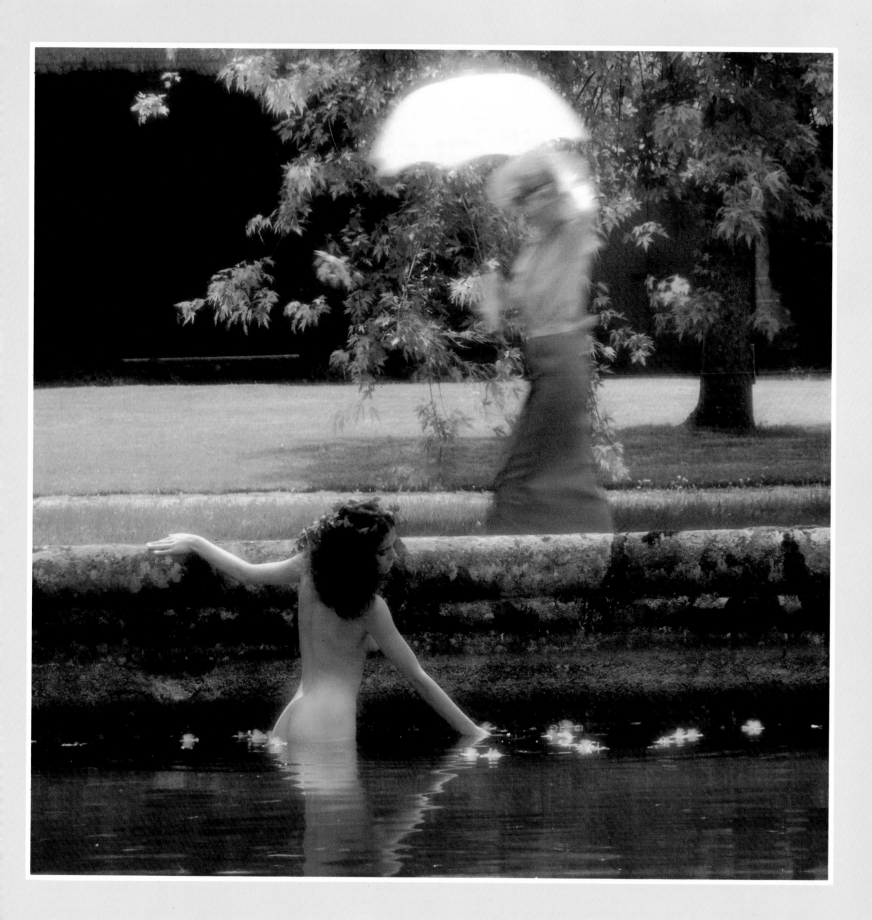

This shot didn't make the Calendar. Niké
caught with an unread book (I think most
books in the fantasy world created by
Lichfield do stay unread). She's pondering,
perhaps, whether the old boy has done her
well in his will: I rather fancy she might be
the widow.

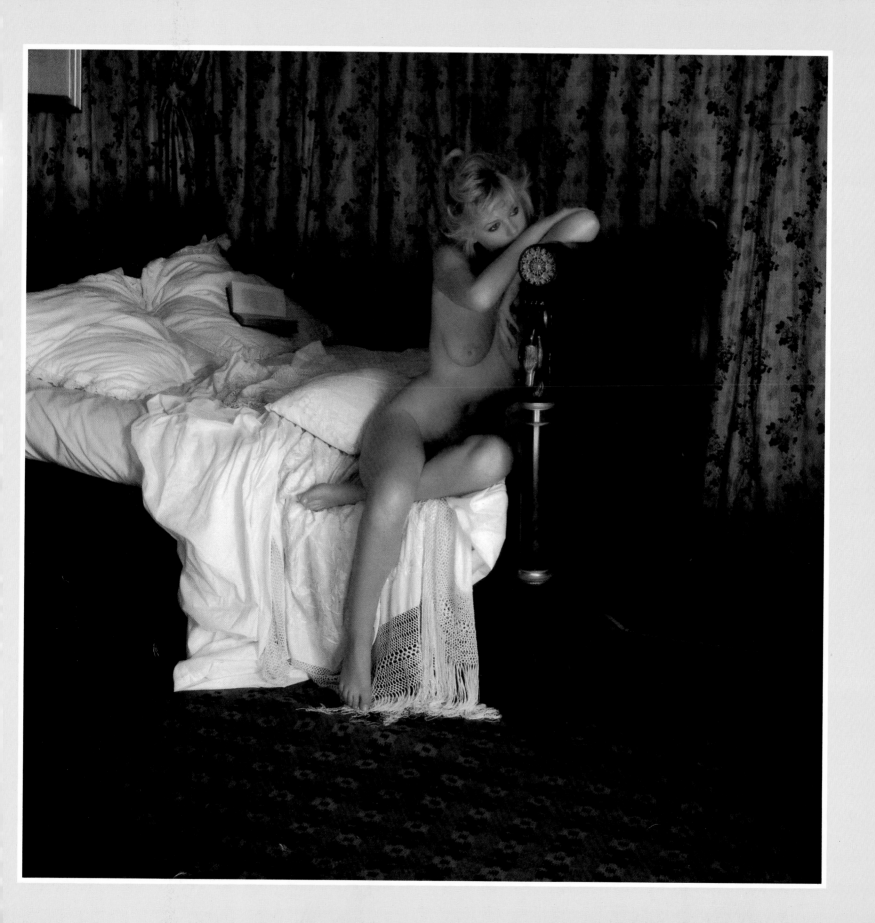

Blind man's buff: Lichfield has a passion for house party games, Lord love him, and here it shows. Personally, I find that sort of fun always ends in tears. . . but, at least in the pictures, the Unipart Calendar knows no serious moments, so Sally will stay laughing for ever, and Niké and Debbie will happily be a pair of blurs till the cows come home.

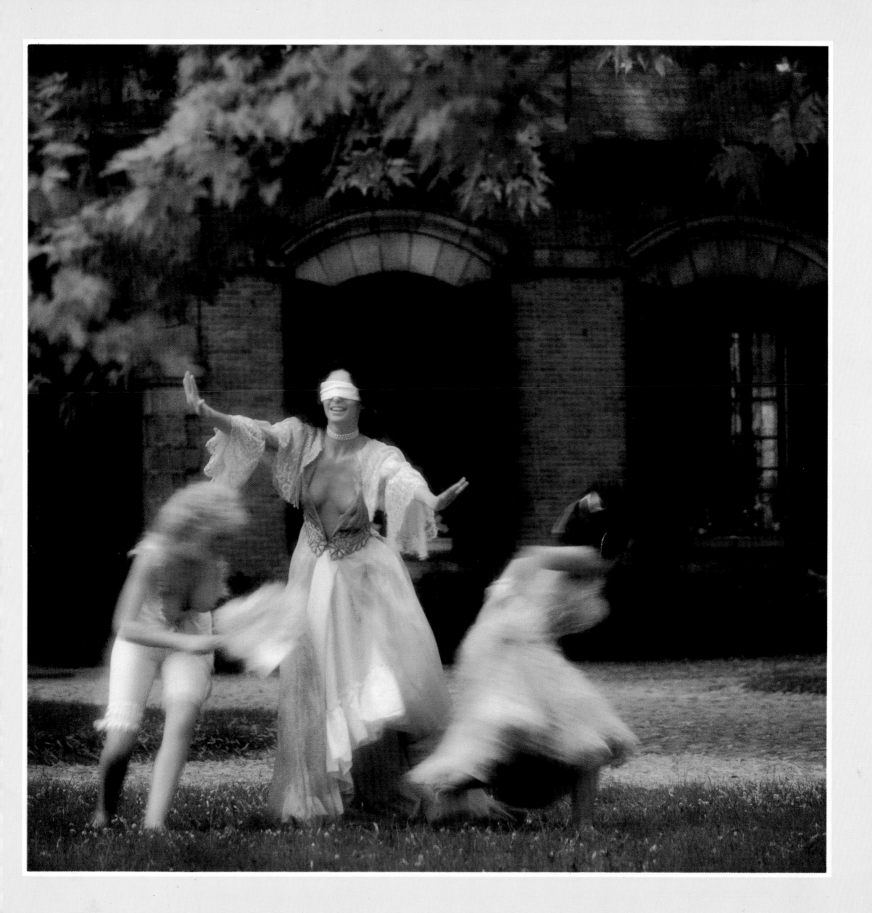

Pursuing the idea that Lichfield is exploring childhood scenes but with bare bits, here is Niké (sitting) and Sally at granny's gear, which has now become the delinquents' dressing-up box. We must hope they don't dress up too much because, sure as eggs, Lichfield will make them take half of it off again.

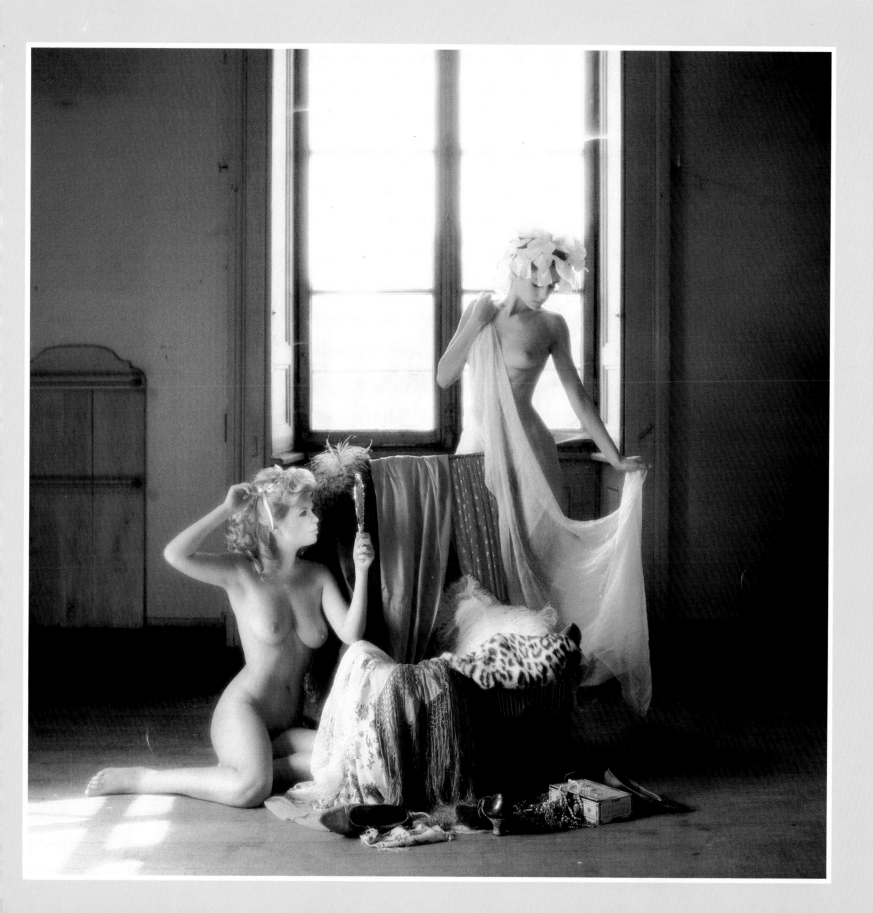

This little strumpet looks to be a none-too-scrubbed village girl the mistress of the house has taken into service. No more tumbles in the hay, and no more tomcatting with village boys in mown fields for her: oh no, it's going to be three-inch baths in cold water under the eye of the housekeeper from now on. Debbie is about to be brought to the realization that cleanliness is next to godliness, and Sally is the streak of discipline by the door.

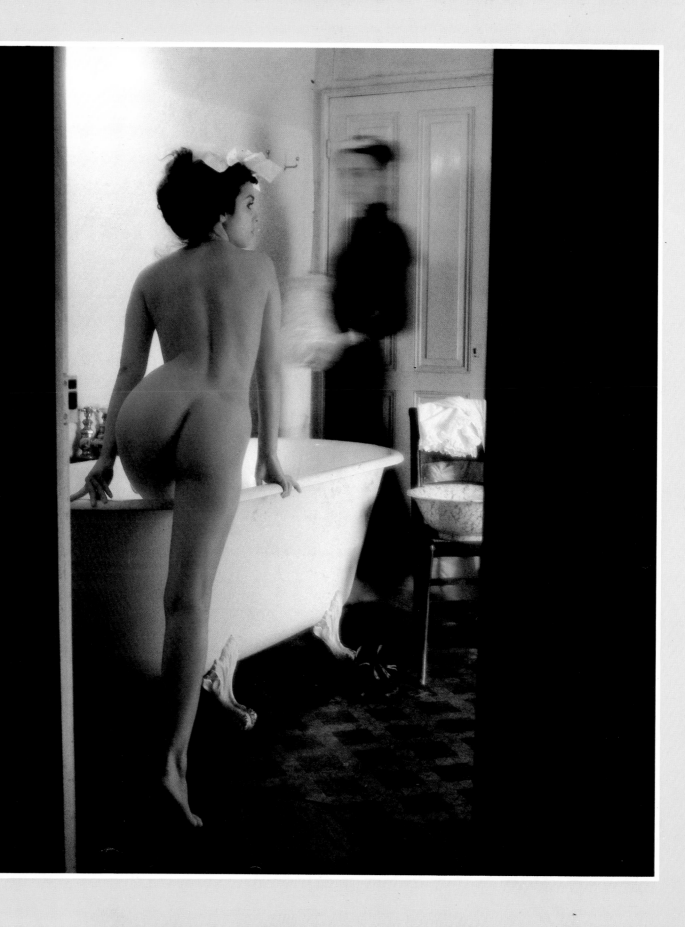

Not Emma Hamilton at her most weak-willed would have thought of posing around in this little number. Debbie, as the lady's maid, is clearly impervious to the aristocratic whims of her mistress, Sally. 'What I say is,' she's thinking, 'it might not do for everyone, but if Madam wants to go about making an exhibition of herself well, just so long as she doesn't make me do it, it's alright by me.' Meanwhile Niké is wondering if she might not persuade old Sal just at least to pop on a petty. The dummy is played by a dummy.

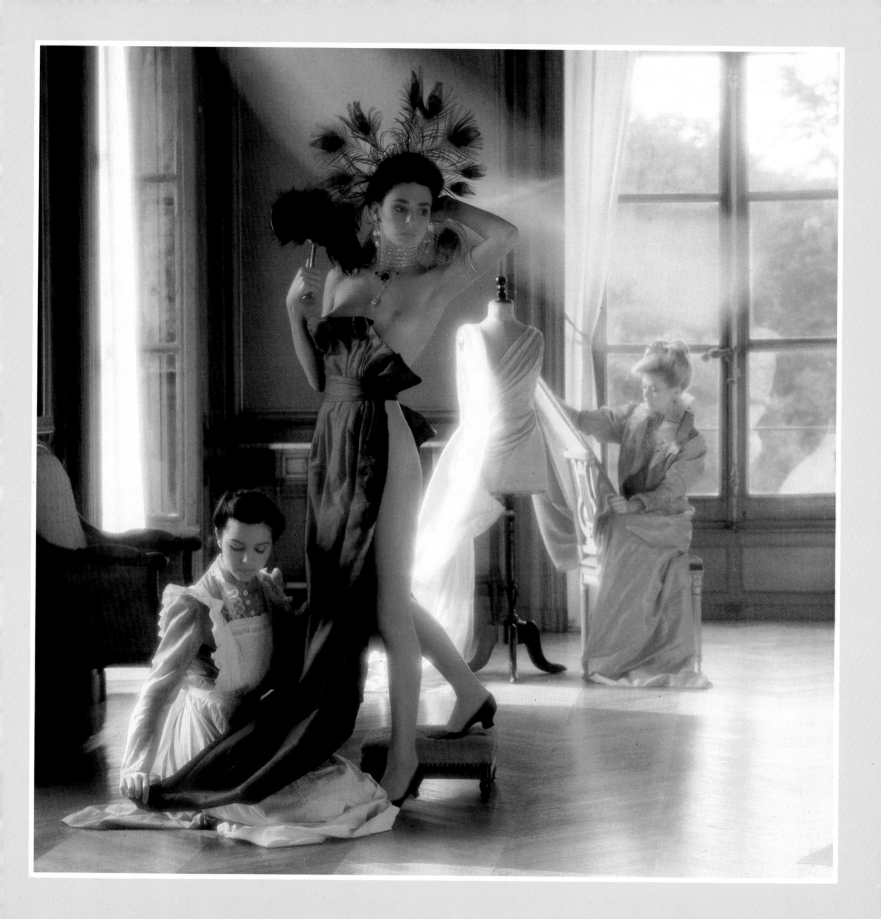

This would rate only because it demonstrates what shapes the perfect back can make: Debbie's spine should be modelled for posterity. Gina looks like some big feline about to pounce... but beyond that it's a fair bet that speculation about what the picture actually *says* is so much speculation squandered.

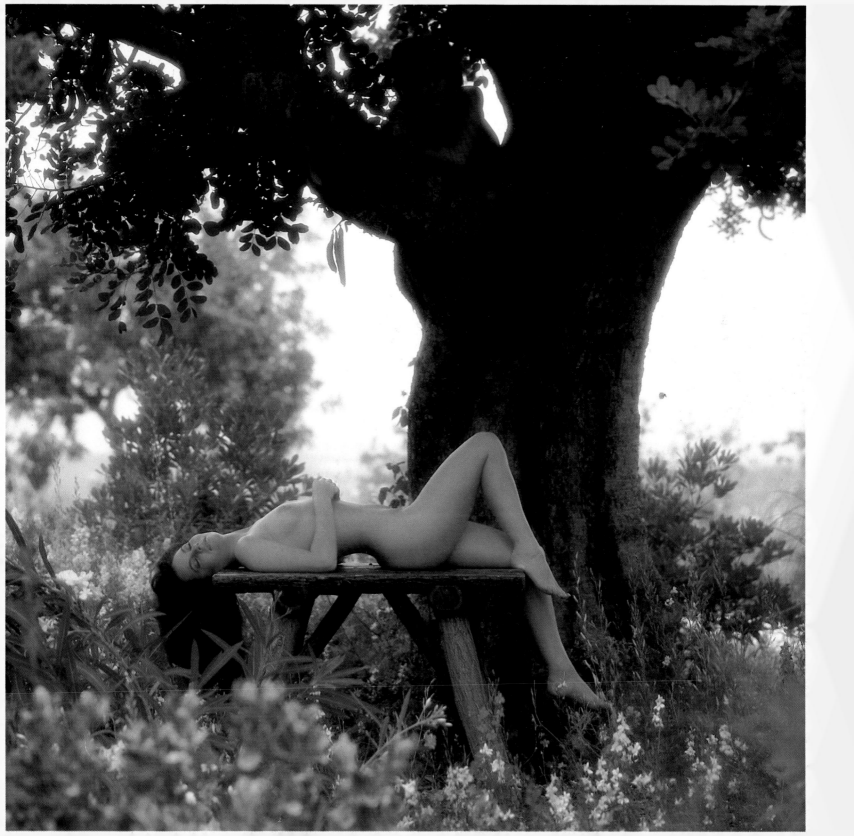

This so-English garden was created on a
barren looking Ibiza hillside at the whim of
a millionaire. It took Unipart to add Gina as
the under housemaid out fruit-spotting for
lunch. If she hangs about much longer
she'll never get the beds done.

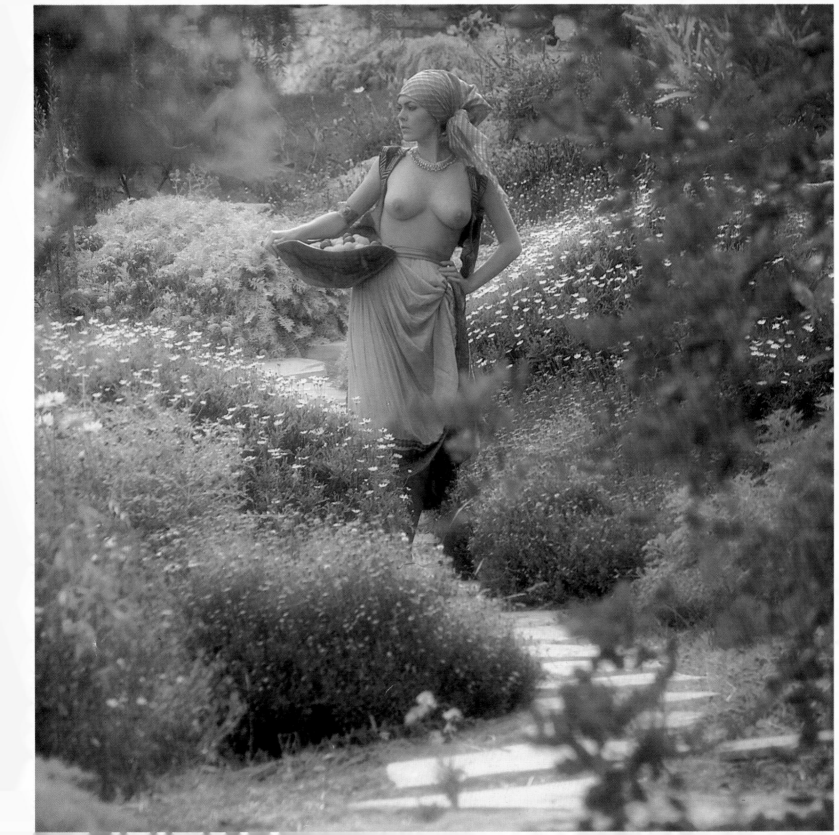

Melissa teaching young Gina how to do really serious macrame. Or are they designing the biggest cat's cradle problem in the world?

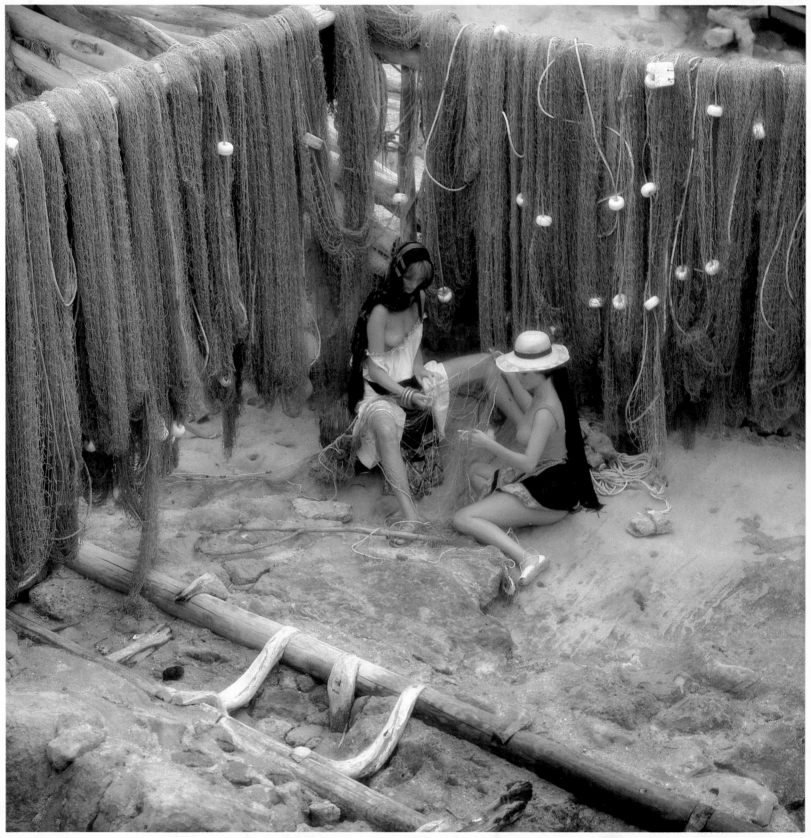

There are all sorts of things you can say for car-parts manufacturers, and I don't believe in biting the hand that feeds unless I have to, but honesty compels one to observe that the blokes who said this shot didn't deserve to be in the Calendar should be sent back to the inspection pit where they belong. Debbie's langorous comfort on those Moorish cushions is very more-ish indeed, for any sensible money.

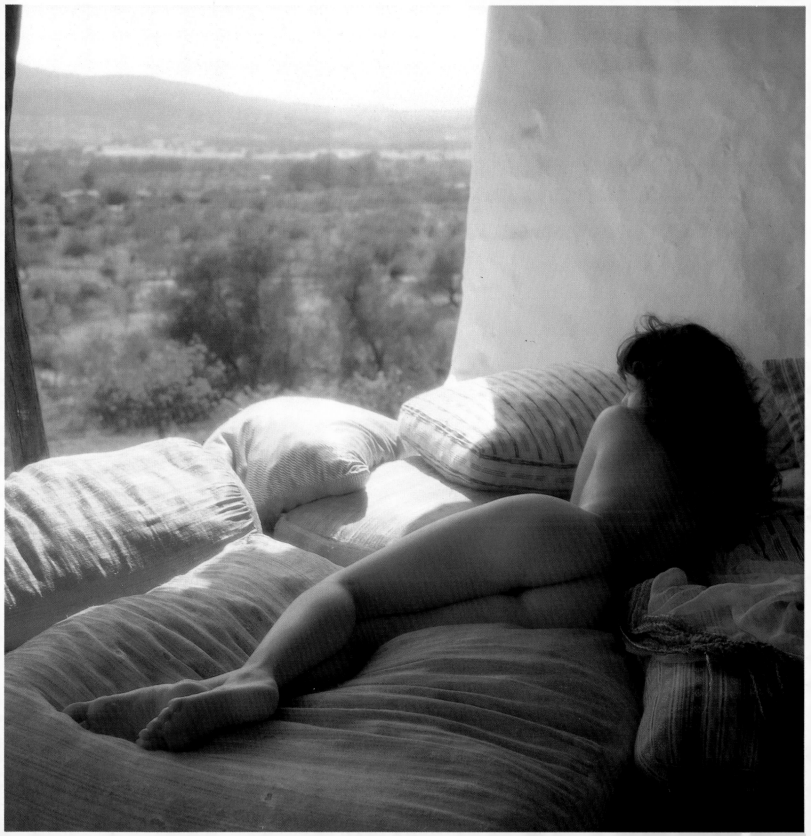

Gina's first picture for the shoot: the sensa-
tive souls amongst us wondered if she
wasn't feeling rather shy. In a pig's ear, said
the knowledgeable women amongst us. . .
she loves it.

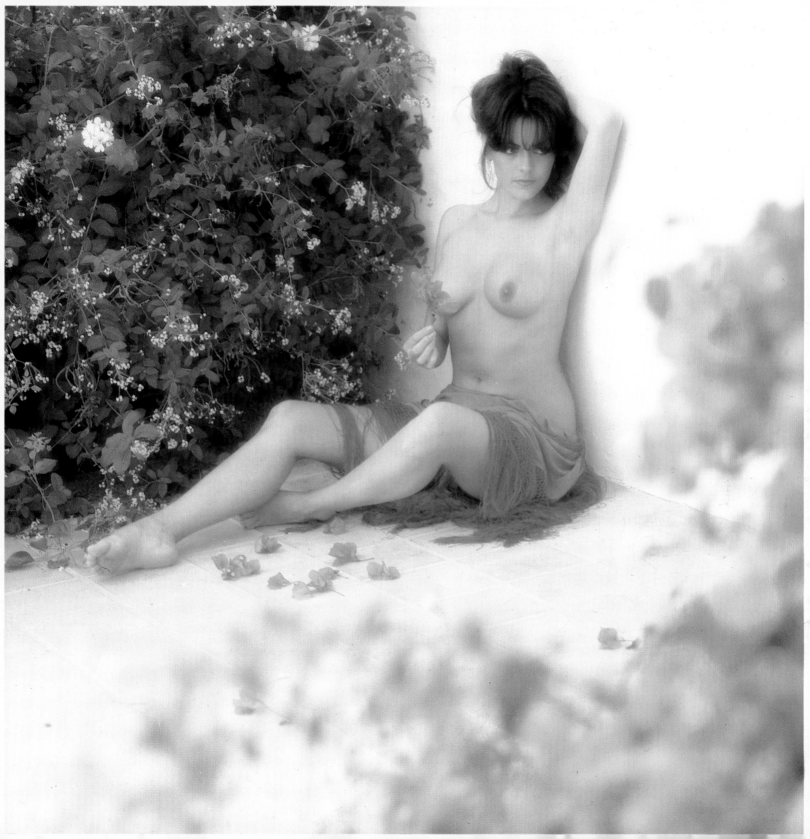

The trade got Debbie doing the full
Spanish number as a taster for the 1984
Calendar. Minutes before, as we saw in
earlier pages, she'd been looking a lot less
seemly.

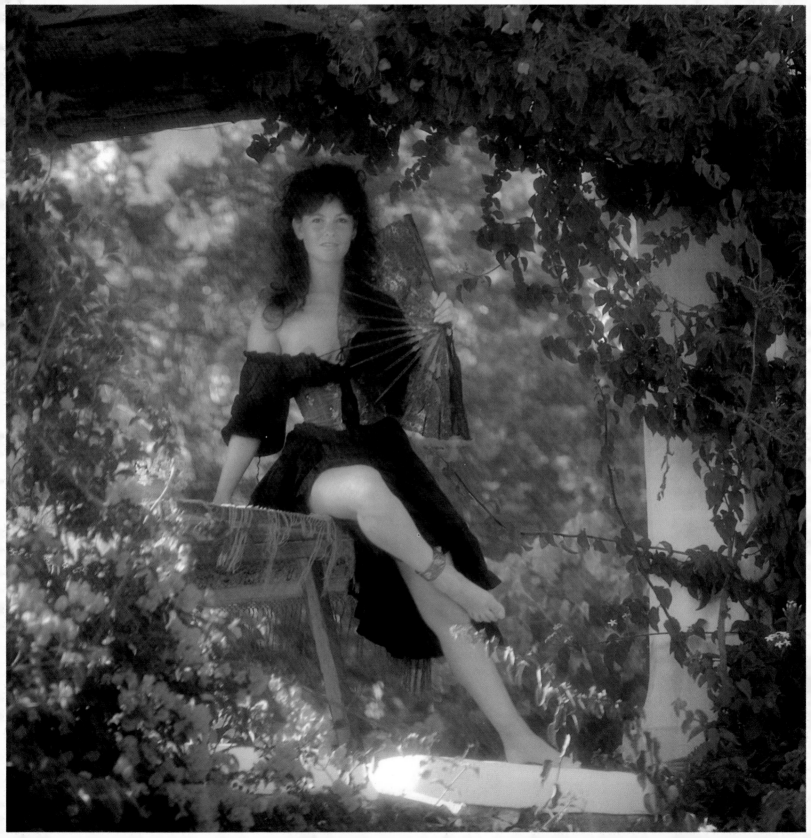

This one didn't make the Calendar. Pity.
Lots of us have a soft spot for window
pictures: something suggestive about
rumpled beds in the gloom within,
perhaps. Anyway. Perhaps it was the small
difficulty that she appears to be doing
something v-signish with her right hand.

As animal handler, it fell to the author to get this dead fish – bought in the market – to hang fetchingly from the Huckleberry look-alike's rod. Those are mosquitoes on the water, but don't think about the real world. . . it gets you nowhere when you're clocking the Unipart Calendar. This picture of Melissa was actually taken at the saltpans. The airport's just to the right.

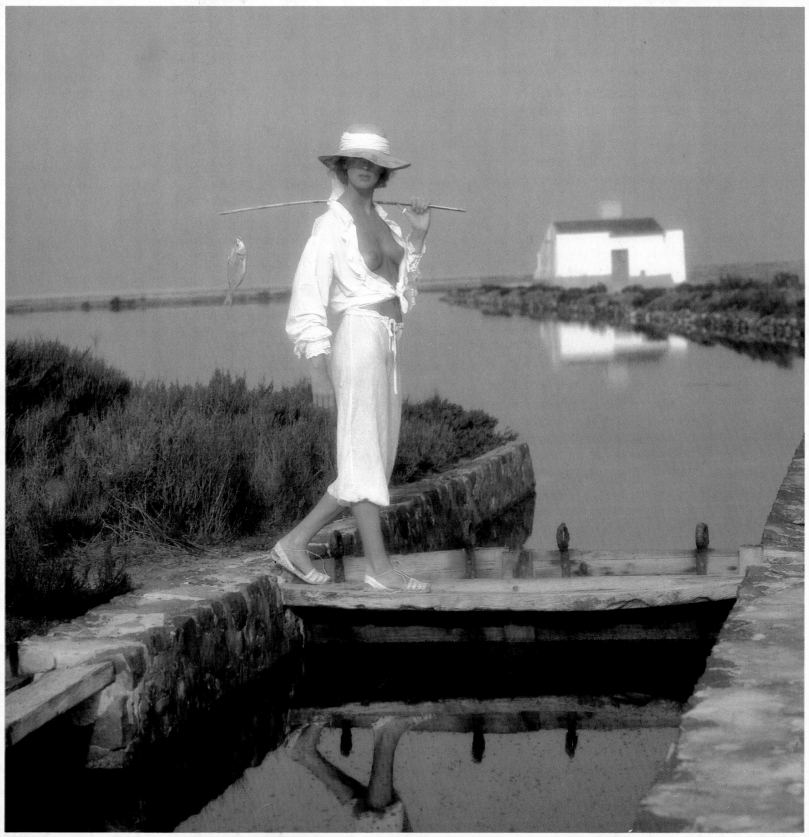

There's a feeling in this picture of Melissa
that she's not all that keen on hay-raking.
She looks as though she'll give the old man
stick for ever thinking that's how she should
spend the afternoon. Definite rat week.

It's not every peasant girl that goes to work in this sort of gear: but read on, gentle reader, and you'll find that the world of the Unipart Calendar has richer and weirder things in store for you even than this. This is Debbie going out to see that the grapes are coming along.

Here's one sheep-minder with other things
on her mind. She's sat down and loosened
her bodice and let her thoughts wander off
almost as far as the sheep... mind you,
hereabouts the sheep can't get far, being
hobbled (as if they'd try swimming to the
mainland, for goodness sake).

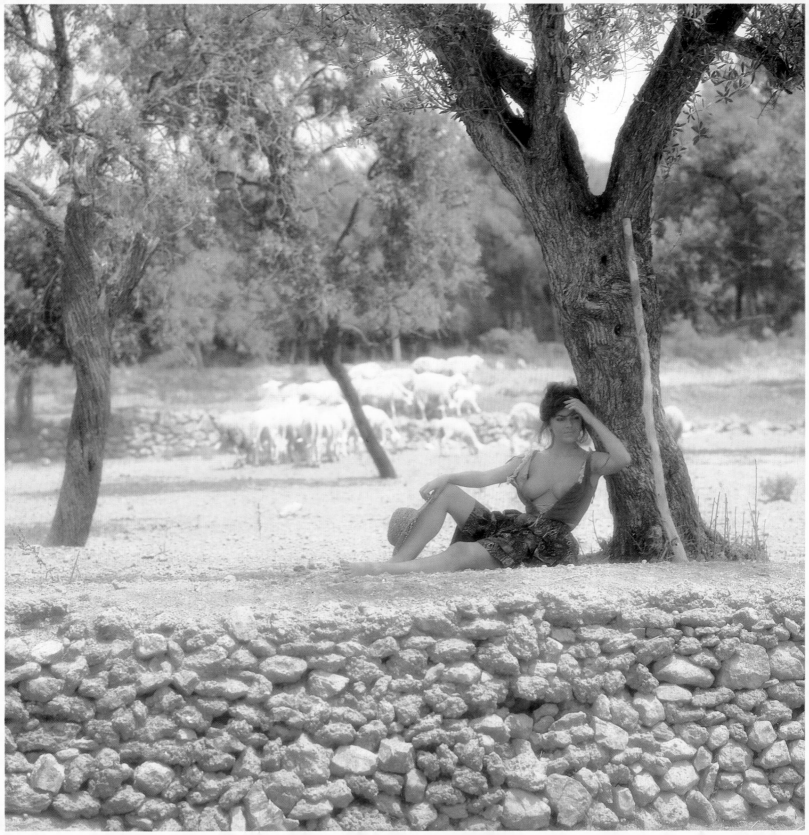

All right, so perhaps they were spoiled for choice when they turned down the Debbie rear-end reclining. It would be hard to decide between her and Melissa here, who reminds one somehow of a Victorian photograph of some dark-skinned exquisite from a desert country. Anyway, the Calendar is bereft without this one.

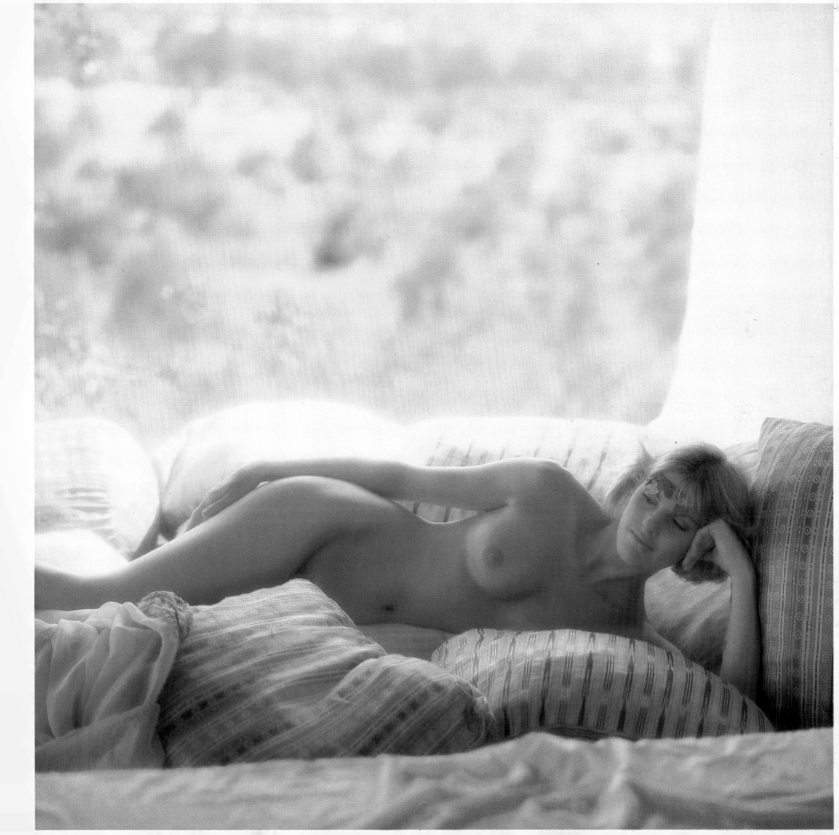

Melissa knows how to play up and play the game with a vengeance. Here, some supposed servant girls are having an afternoon off. It took a foreground stuffed with reflectors to get enough light on to Gina, in this richly-flowered sheltered sunken garden.

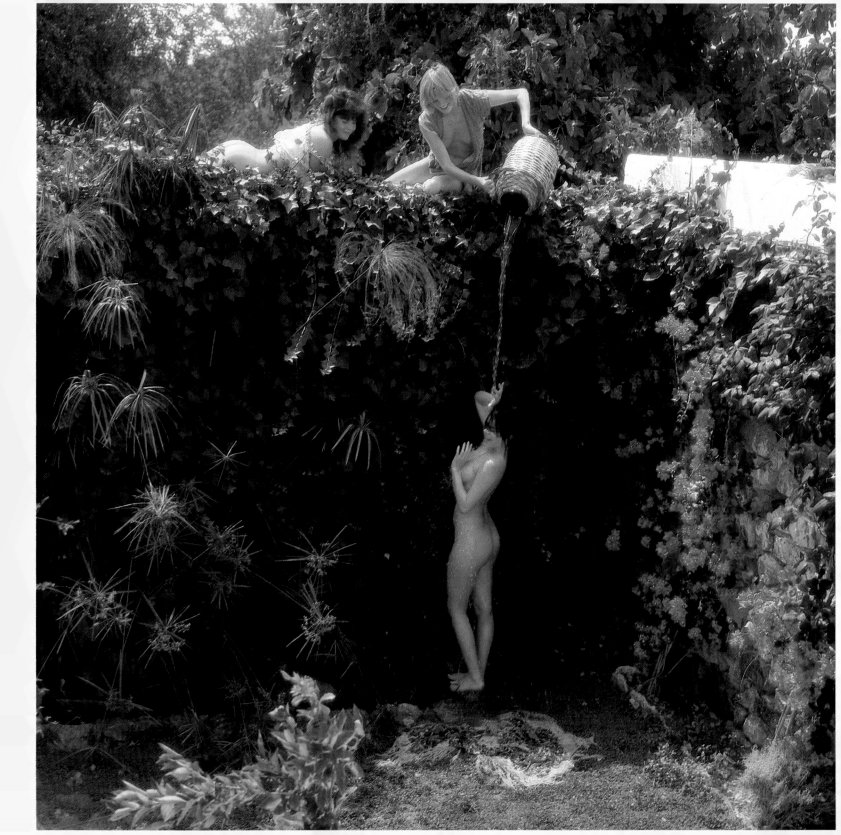

I always thought this picture of Melissa was
a bit too Maid Marian really to work for the
Calendar. Shades of Sherwood Forest come
to the Mediterranean. Noel had thought of
rubbing the ladder down with tea bags to
make it look older, but even that wouldn't
have done the trick, for me at least.

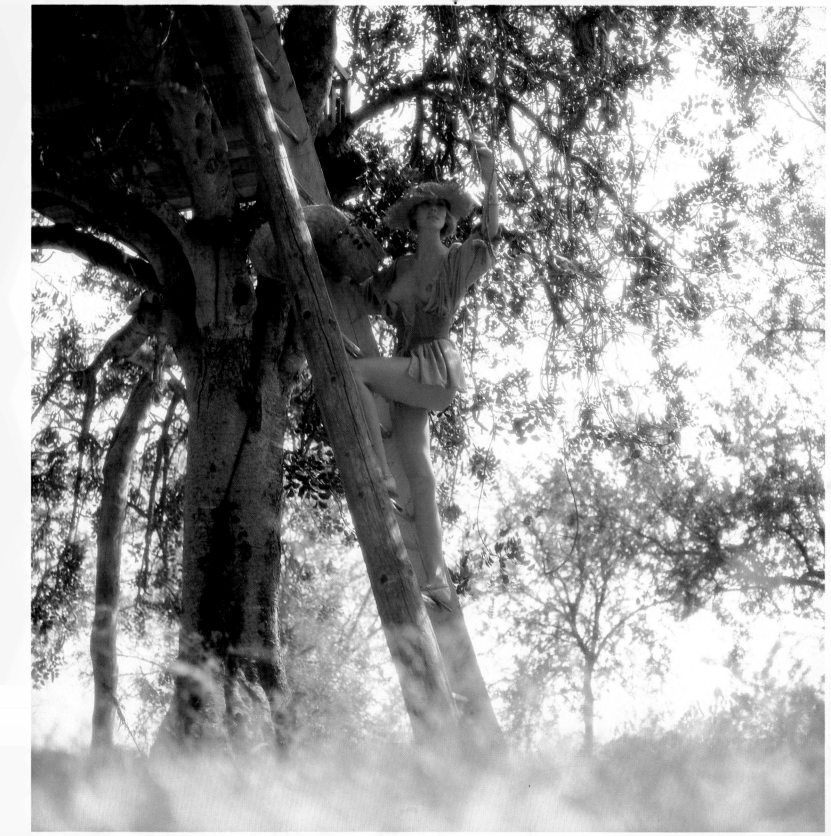

Sinbad Gina saunters down the sandstone
steps to the fishermen's bay.

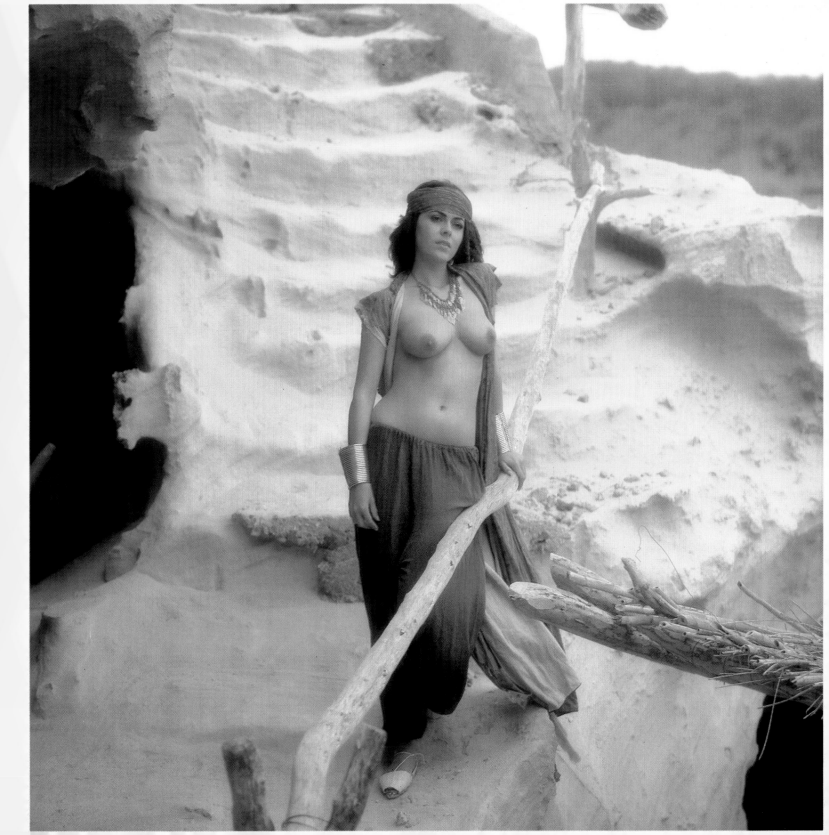

We worked darn hard for this one: Debbie
was forever scrambling about on sharp bits
of rock, whilst we were perched on ledges
all over the place. . . what with sophisticated
a warning system for wave-spotting, and a
few bruised knees, I frankly think it's a
shade ungrateful of old Unipart to have
elbowed it.

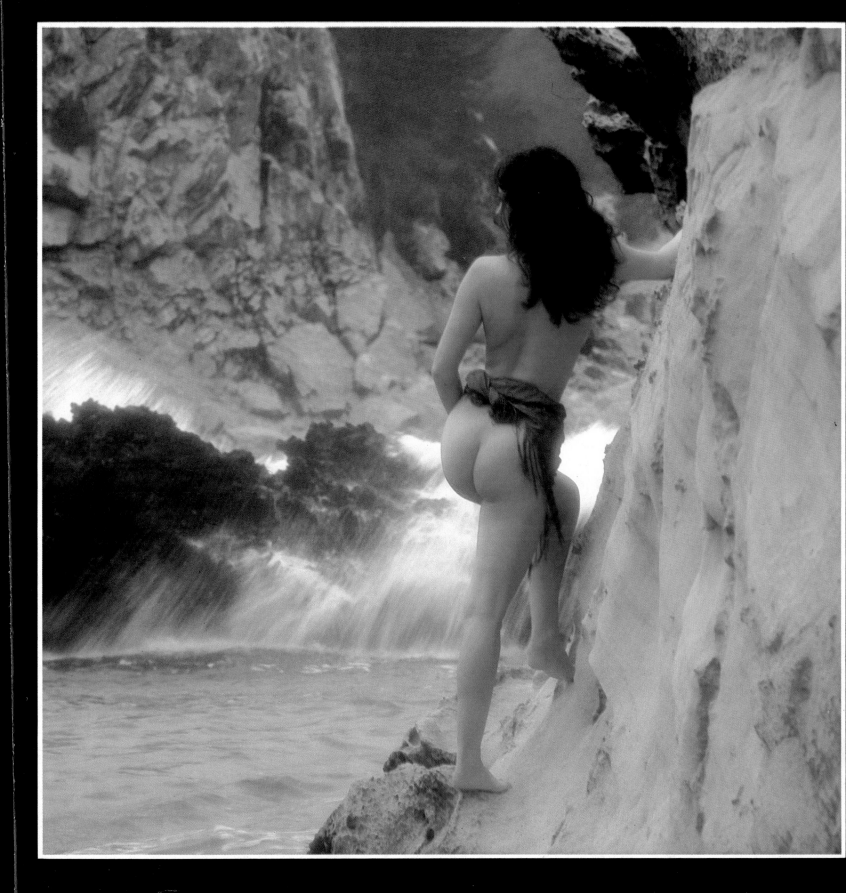

Melissa tickling the goat's fancy. It fell to yours truly to be animal handler for the trip: it was a nice goat, and frankly I think his Lordship might have worked a bit harder to show his best side. Goats have feelings, too, you know, and this one was definitely sensitive.

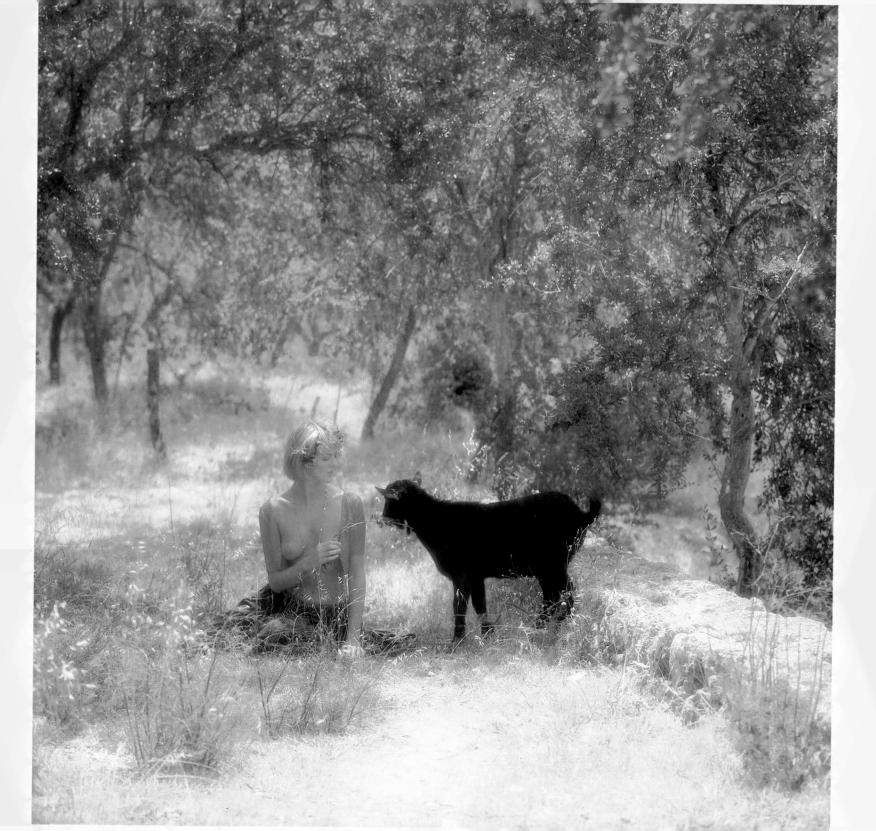

You won't get a more back-lit picture than this. Debbie (in the water) giving the horizon a bit of a gander, whilst Gina concentrates on the important business of making the most sculpted shape of her body that can be mustered.

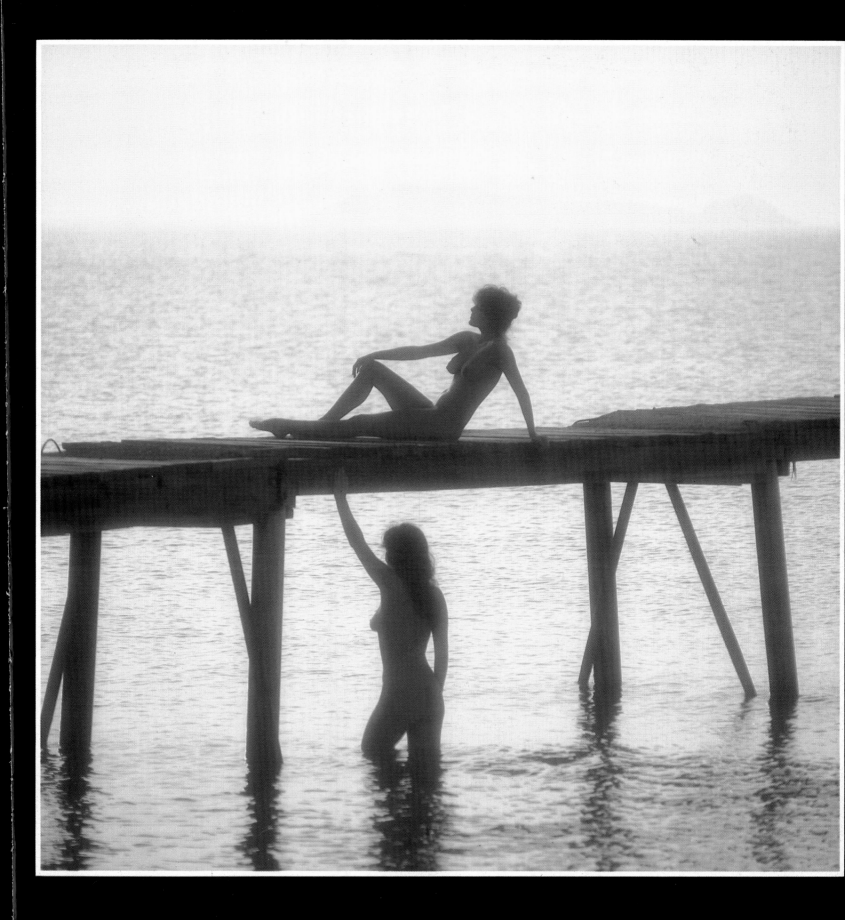

PATRICK LICHFIELD. Photographer. More properly known as Thomas Patrick John Anson, the 5th Earl of Lichfield, Viscount Anson and Baron Soberton, he left the army in 1962 to make his own way in the world. He had done well in the Grenadier Guards, and is still proud of his regiment and his time with it, but decided to fly in the face of family advice (it was that he should avoid being an interior decorator, ballet dancer or photographer).

In the tough world of the King's Road, young Lichfield – then aged 23 – did not immediately take the world by storm. He knew and got along well with the East End clan of Bailey and Donovan and Duffy, and has the traditional scrapping aristocrat's admiration for go-getters, especially if they've come across from the wrong side of the tracks. His life has been an essay in the most tumultuous period in the English class system (our national sport, hobby, artform and bane), and the upshot has been that he has found an extremely profitable and sustaining niche within it. But he's done it by quite a lot of talent and – what is harder to come by – a terrific capacity for hard work.

He has gone from being a society-pages party-snooper to establish himself as an accomplished portraitist and advertising photographer – and, of course, as the man who dares wring informality from royal team photographs in the sort of way which might have earned him an attainted earldom if he'd been a painter and tried it a few centuries ago.

NOEL MYERS, Art Director. A one time hard tennis player and all time good timer, Noel's work on the Unipart well predates Lichfield's; he has always been the eye which knows exactly what the punter wants. He enjoys the freshness and innocence of a Lichfield picture, but knows as no one else the essentially peculiar business of getting girls to up-and-at-it in the glamour department.

For a man who is such good company and so useful in a bar, he also knows when to take a walk and think, or to tuck his head under his wing and get some sleep. He is a good bloke to have a talk with if you're feeling blue, and – as the models on any shoot would readily testify – an extraordinarily reliable comforter when the confidence is bruised; he makes them look very sexy, but he does it by seeming to them to deliver his instructions in the manner of a slightly raffish old friend. Of all the men in the team, he is the girls' most useful mate. Which is saying something for a man tempered, but not hardened or desensitized, by the world of advertising, his usual stamping ground.

CHALKY WHYTE AND PETER (PEDRO) KAIN. Lichfield's assistants. It says a good deal for these two very different characters that they can be talked of in the same breath. With over a decade each on the Lichfield Studio payroll, they are both fine photographers. Lichfield hangs on to them as assistants by virtue of giving them a good deal of rope. They have not hung themselves, so far, but instead are able to spend part of any year on projects of their own.

Amongst their strengths is the severely testing ability to spend much of their time in the shadow of a star. They've heard the Lichfield stories and watched the Lichfield temperament through innumerable shoots. They know their man at work and play, under pressure and relaxed: their jobs entail that they get more of the stick and fewer of the perks of the photographers' only occasionally genuinely glamorous trade. But they seem fond of – if sometimes exasperated by – their boss. And, mostly, he seems to remember pretty generously what he owes to them for their attention to detail.

SEBASTIAN KEEP. The Producer. He looks like a cross between a Beachboy and Our Man in Havanna. He is. A confirmed surf-bum for years, a good photographer, he knows the best of the well-off and the competently broke in a couple of useful continents. He possesses the eye that knows a good location, and the mind which can run a quick calculation on its cost for a film or photographic crew.

JACKIE CRIER. The Stylist. The mother of two sturdy boys, sired by the above and much loved by him, she is one of London's most successful providers of accoutrements and nicknacks, and the good taste with which to deploy them, for advertisers and film-makers. Her next baby should be with us in force by Christmas; in the meantime, she was a force about equally powerful and aesthetic on the Unipart shoot.

CLAYTON HOWARD. The Make-Up Man. Clayton Howard was just a plain window-dresser, once upon a time. But he went to Max Factor's studio and all that was radically changed. He has dabbed at notable faces from the then, but only in one sense, plain Lady Diana Spencer to the always radiant Katie Boyle. His experience includes gilding the lily for Gary Glitter. He understands the needs of a camera: he can spot just what to do with a face which will make it speak in very clear terms to a lens. He also knows how to deal with girls: it is his especial task to be the man who drapes drapes and hangs those importantly tantalising bits and pieces over their off-limits districts. He is the Trusty.

SOPHIE GRAHAM. This was only Sophie's second shoot for Unipart. She works for Cheevers, a classy London salon, where she has achieved the kind of reputation that makes some people fly her to the Continent so that their barnets can receive exactly the right treatment before special do's. Her second shoot, maybe: but she is firmly a part of the crew for all that.

THE MODELS. Only one girl, **Melissa Stockdale,** has ever been on a Unipart shoot twice: she was in Kenya for the 1981 Calendar and was with us in Ibiza. She had a kind of seniority, then, which came from experience – at least in part. The truth is that she has been in the business long enough – though only in her early twenties – to have natural authority compounded by what she's seen. All girls who trade on their beauty have to learn even more than ordinary, amateurly beautiful women that they possess the looks which make men silly and women envious. They have to learn to handle the sort of admiration from men which can turn a girl's head without much benefiting her in any other way. Melissa seems to know all that as though some fairy godmother had whispered it to her in her cradle.

Not, mind you, that young **GINA NASH,** or **DEBBIE TARRANT,** were actually at sea. Far from it. But I realized that there was a kind of gulf between them and me that never was bridged. Beautiful and kindly though they were – and they were both – they seemed to have come from another world from mine. Their lives seemed to have been so nice and so unruffled that I dare hardly speak to them without feeling that I was like a mechanic with grubby paws asked to shake hands with a white-gloved vicar's wife at a tea party.

THE 1984 UNIPART CALENDAR
IBIZA '84

will reveal the twelve
pictures finally selected for inclusion

The Calendar is now available from:

**ALAN BATES,
UNIPART,
UNIPART HOUSE,
GARSINGTON ROAD,
COWLEY, OXFORD**

Just send your name and the address to
which you would like the Calendar sent, and
a cheque for the privilege order price
of £5.75 (including VAT and p&p),
made payable to
Unipart Group Limited.

No beauty she doth miss,
 When all her robes are on;
But beauty's self she is,
 When all her robes are gone.
 Anonymous